THE MASTER GUIDE TO DRAWING ANIME
TIPS & TRICKS

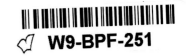

DRAWING WITH *Christopher Hart*

THE MASTER GUIDE TO DRAWING ANIME
TIPS & TRICKS

Over 100 Essential Techniques to Sharpen Your Skills

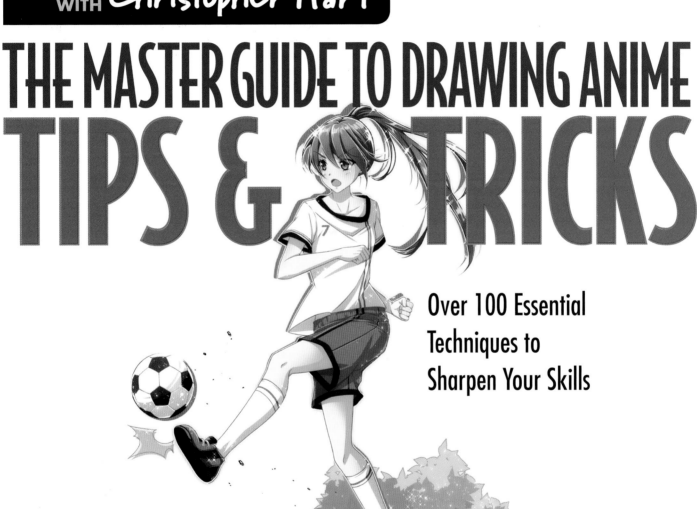

 Get Creative 6

DRAWING WITH Christopher Hart

An imprint of **Get Creative 6**
104 West 27th Street, New York, NY 10001
sixthandspringbooks.com

Managing Editor
LAURA COOKE

Editor
LAURA COOKE

Art Director
IRENE LEDWITH

Editorial Assistant
JACOB SEIFERT

Production
J. ARTHUR MEDIA

Contributing Artists
AKANE
AYASAL
ERO-PINKU
INMA R.
KAGURA
NACHOZ
TABBY KINK

· · · · · · · · · · · · · · · ·

Vice President
TRISHA MALCOLM

Chief Operating
Officer
CAROLINE KILMER

Production Manager
DAVID JOINNIDES

President
ART JOINNIDES

Chairman
JAY STEIN

Library of Congress Cataloging-in-Publication Data
Names: Hart, Christopher, 1957- author.
Title: Tips & tricks: over 100 essential techniques to sharpen
your skills / by Christopher Hart
Description: First edition. | New York: Christopher Hart Books,
2018. | Series: Master guide to drawing anime | Includes
index.
Identifiers: LCCN 2018007207 | ISBN 9781640210233
(paperback)
Subjects: LCSH: Cartooning--Technique. | Drawing--
Techniques. | BISAC: ART / Techniques / Cartooning--
Technique. | Drawing--TechniquesClassification: LCC NC1764
.H384 2018 | DDC 741.5/1--dc23

2018007207

MANUFACTURED IN CHINA

5 7 9 10 8 6

christopherhartbooks.com
facebook.com/CARTOONS.MANGA

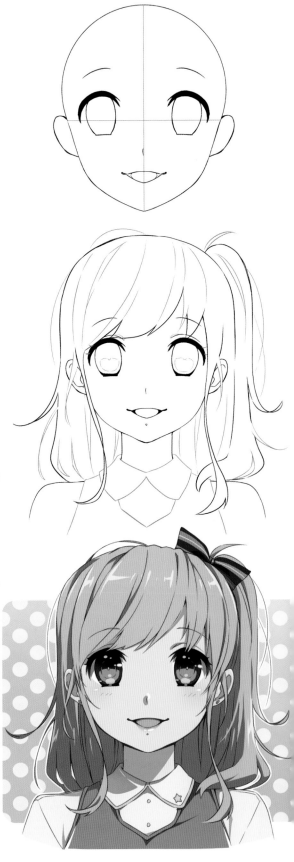

This book
is dedicated
to an aspiring
anime artist:
You!

www.youtube.com/
chrishartbooks

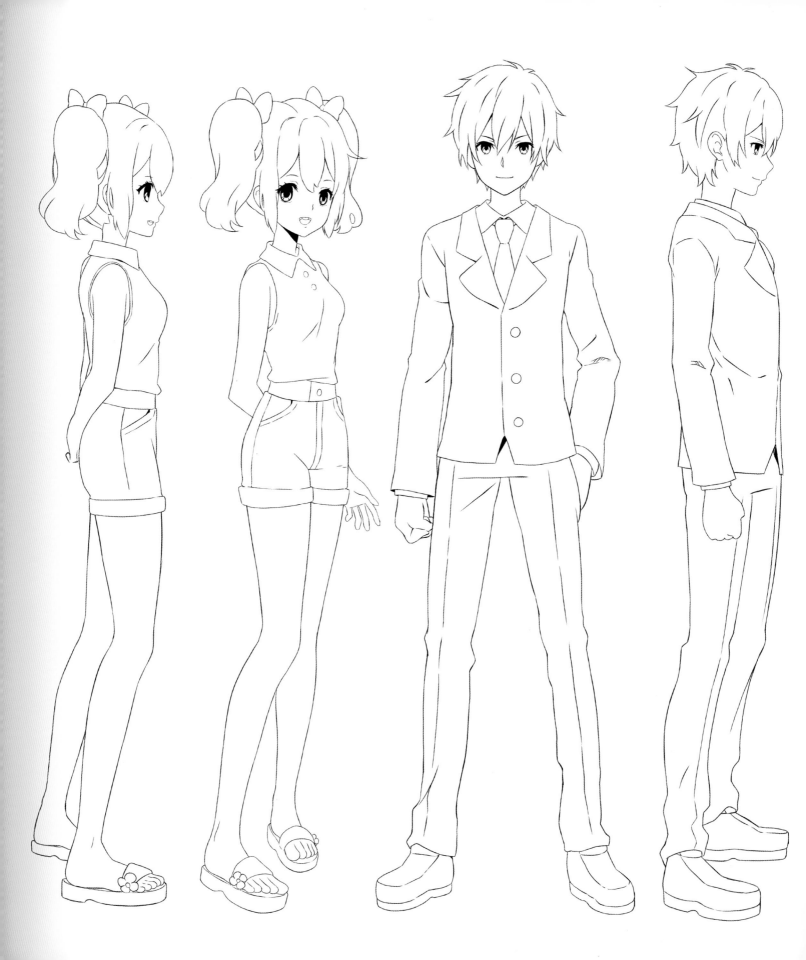

Contents

Introduction

This book is the ultimate resource for the aspiring anime artist.

If you want to improve your drawing skills, this book will show you how. With an assortment of helpful tips and tricks, you'll learn how to draw all popular character types. All of us have encountered sticking points when we draw. Where do you go for answers? This book will give you the information you need to draw faces and expressions, bodies and poses, basic proportions, and even hands, feet, shading, color, and backgrounds. Each chapter introduces new techniques and popular subject matter. There are more than 100 hints that will make drawing anime clear, simple, and fun. ■

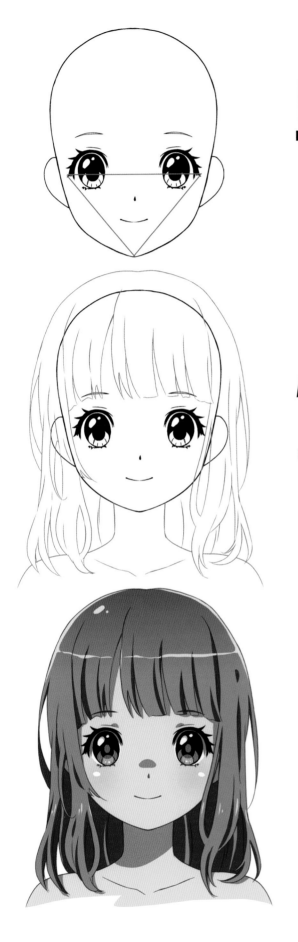

Everything You Need to Know About Drawing the Head

In this chapter, we'll cover all the basics of drawing the male and female anime head. We'll focus on the eyes, hair, and maintaining the look of the character at different angles (called *head turns*). You'll also get hints for adding finishing touches, which is always fun to do. Each lesson is clearly demonstrated with an abundance of steps, giving you the roadmap to get your drawings right from the start. So...let's get started! ■

Secrets to Drawing Shiny Eyes

You can't draw anime characters until you know the trick for drawing this luminous feature of the face. In this chapter, we're going to put our focus on one technique: How to make the eyes glow.

EYE—FRONT

Start with two basic shapes: a curved eyelid and an oval eye.

The eyelids are feathered.

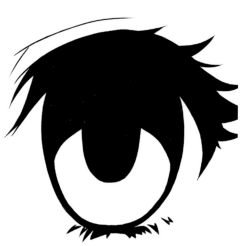

Draw the pupil in the center of the eye, and draw a curved shadow over the top half of it.

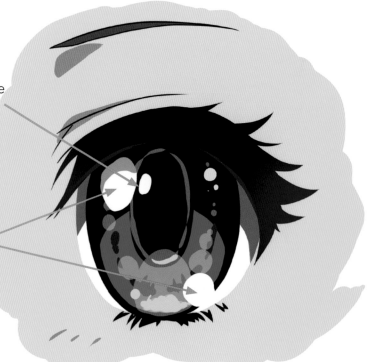

Draw a small shine on the pupil.

Draw two big shines on the iris.

EYE—SIDE

Eyelashes extend off the front.

Notice the crease line just above the upper eyelashes.

A shadow covers the top of the pupil, leaving the bottom ready for color.

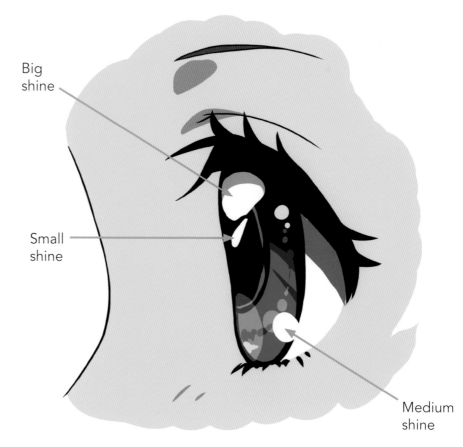

Big shine

Small shine

Medium shine

Drawing the Anime-Style Head—The Basics

What is it that gives an anime face its appealing look? The answer lies in its simple shape. With these tips, you can get amazing results.

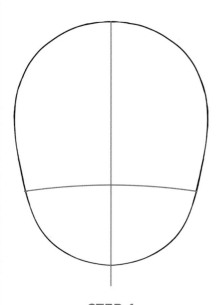

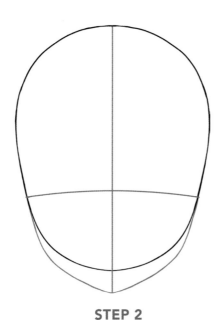

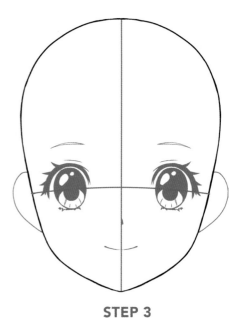

STEP 1
Draw the head shape like a boxy oval. It doesn't have to be perfect (really!).

STEP 2
Once the shape of the head is drawn, modify it by lowering the chin. That's the secret!

STEP 3
Space the eyes far apart. The eyebrows and mouth are drawn with a short line.

PROPORTIONS TRICK
You should be able to draw an equilateral triangle from the eyes to the chin.

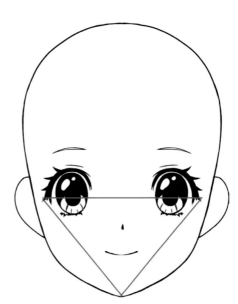

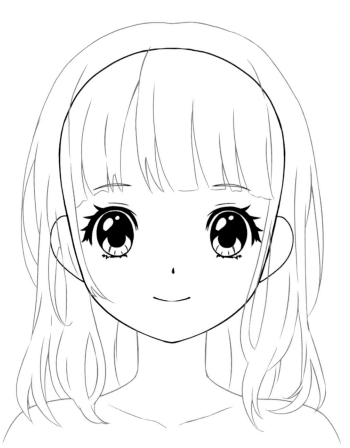

TRICK

Start simple, and add details once the basics are in place.

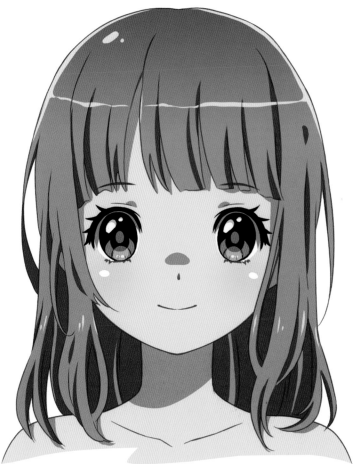

STEP 4

Hair is such an important feature for character design. Think about what it says about a character. This cute girl is drawn with cute bangs.

STEP 5

The interior of the hair is darkened to create depth. For black and white drawings, you can do this with pencil shading.

Drawing the Girl's Head in Five Easy Steps

We're still going to keep it simple, but now we're going to add a few finishing touches for fun. Using the same basic head shape as the character from the previous page, we can create an entirely new character.

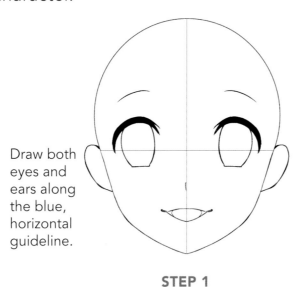

Draw both eyes and ears along the blue, horizontal guideline.

STEP 1

PROPORTION TIP

The mouth is as wide as the space between the eyes.

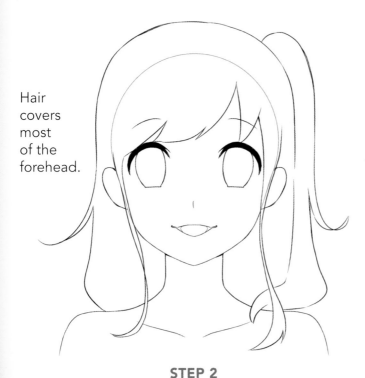

Hair covers most of the forehead.

STEP 2

The nose only needs a small indication.

Adjust the chin to soften the look.

STEP 3

THE FINISHING TOUCHES

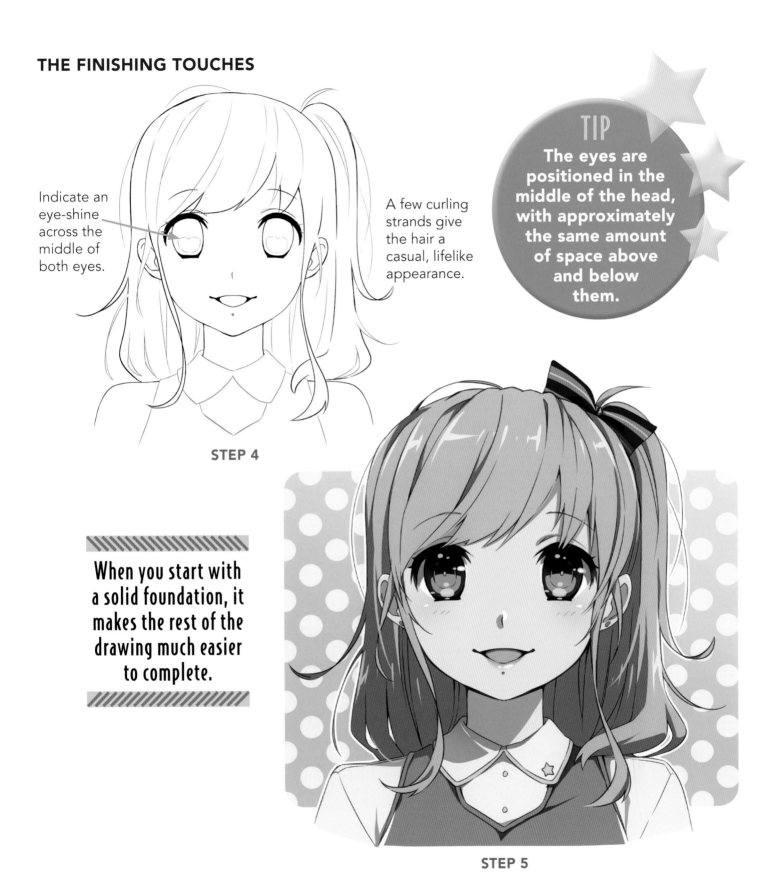

Indicate an eye-shine across the middle of both eyes.

A few curling strands give the hair a casual, lifelike appearance.

TIP

The eyes are positioned in the middle of the head, with approximately the same amount of space above and below them.

STEP 4

When you start with a solid foundation, it makes the rest of the drawing much easier to complete.

STEP 5

Drawing the Boy's Head in Five Easy Steps

The construction of the boy's head is not as round as the girls. His jawline is lower and more angular. These simple tricks give the male face a sleeker look. They can be adjusted to create different character types.

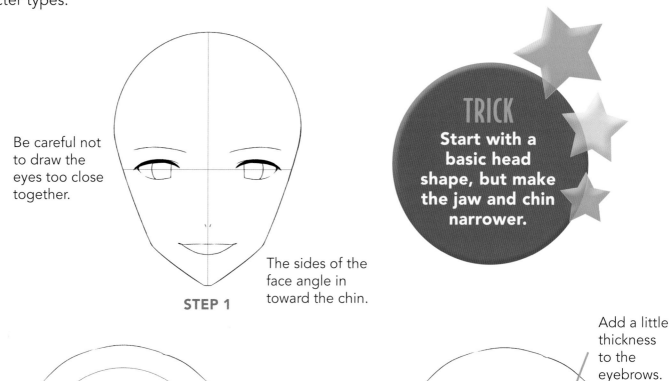

Be careful not to draw the eyes too close together.

The sides of the face angle in toward the chin.

STEP 1

TRICK
Start with a basic head shape, but make the jaw and chin narrower.

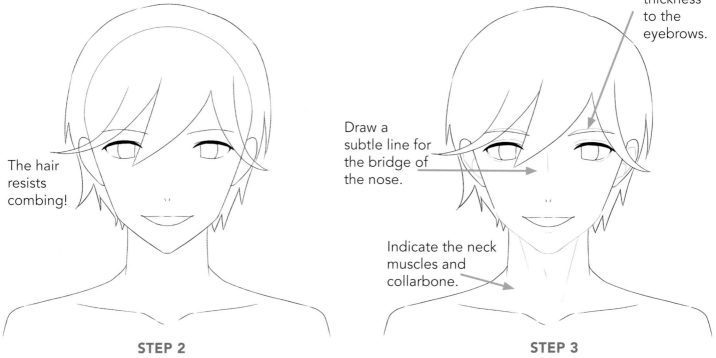

The hair resists combing!

STEP 2

Draw a subtle line for the bridge of the nose.

Add a little thickness to the eyebrows.

Indicate the neck muscles and collarbone.

STEP 3

THE FINISHING TOUCHES

Draw pointed streaks within the hair, for an authentic, anime look.

Draw small shines at the bottom of the eyeballs.

TIP
Eye shines aren't always white. You can use a bright color instead.

A few colorful highlights are a good idea, like orange streaks on red hair.

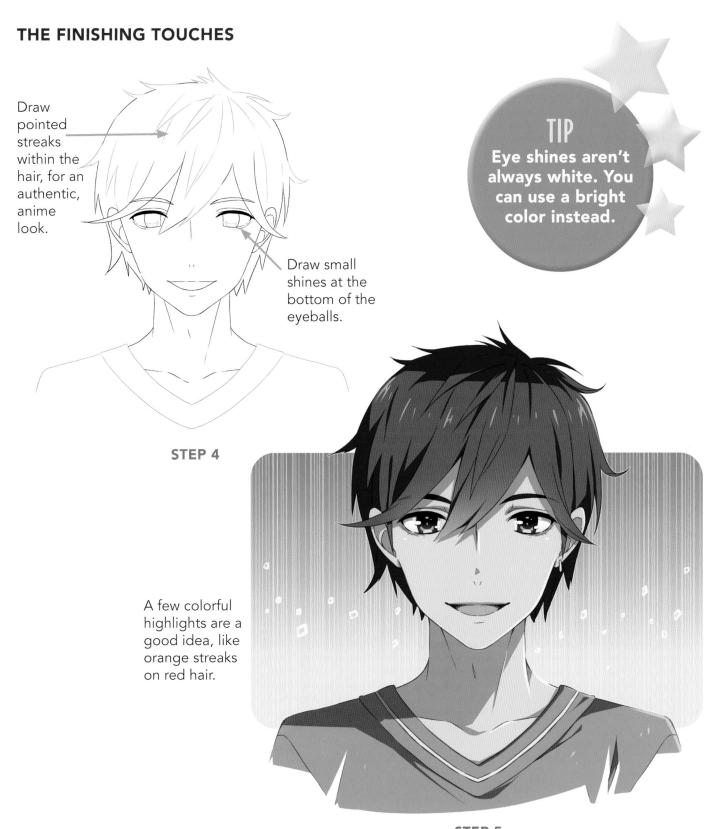

STEP 4

STEP 5

TIPS FOR DRAWING THE 3/4 ANGLE

Many beginners have trouble drawing a head at this angle due to a few subtleties inherent to it. By following a few helpful tips, you can master it.

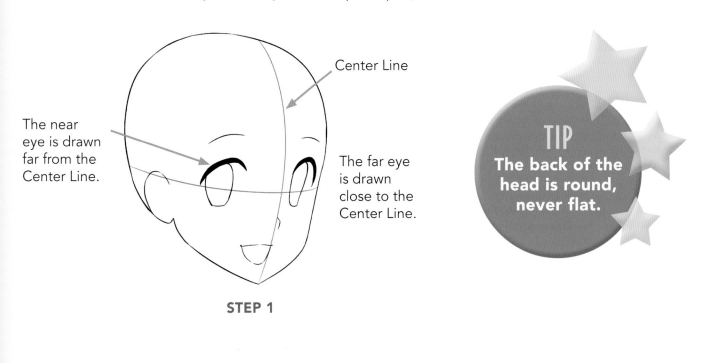

Center Line

The near eye is drawn far from the Center Line.

The far eye is drawn close to the Center Line.

TIP
The back of the head is round, never flat.

STEP 1

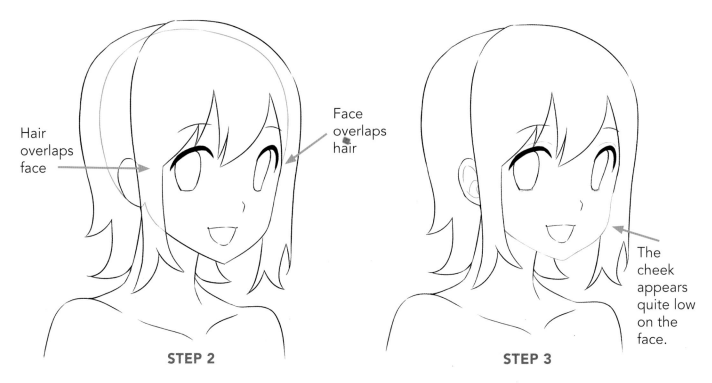

Hair overlaps face

Face overlaps hair

STEP 2

The cheek appears quite low on the face.

STEP 3

THE FINISHING TOUCHES

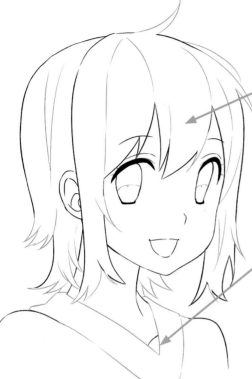

Draw thick strips of hair. This is a popular technique for creating anime hairstyles.

Draw the "V" collar off to the side, adhering to the ¾ angle.

STEP 4

TIP
Drawing the pupils in the corners of the eyes creates a cute expression.

Add a few blush marks under the eyes.

STEP 5

¾ ANGLE—BOYS

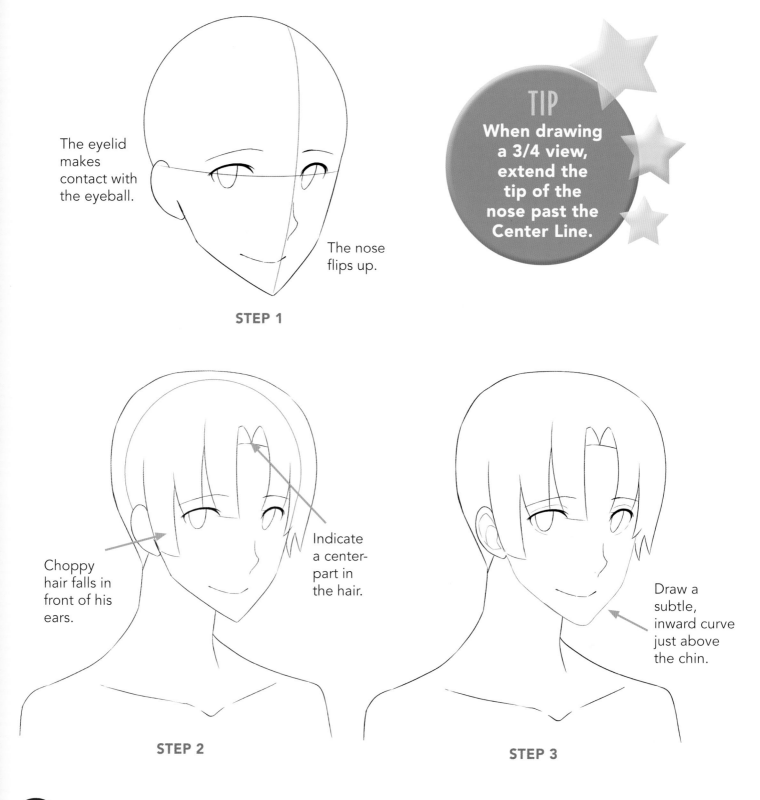

The eyelid makes contact with the eyeball.

The nose flips up.

TIP
When drawing a 3/4 view, extend the tip of the nose past the Center Line.

STEP 1

Choppy hair falls in front of his ears.

Indicate a center-part in the hair.

STEP 2

Draw a subtle, inward curve just above the chin.

STEP 3

THE FINISHING TOUCHES

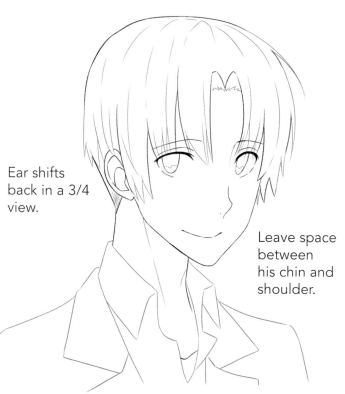

Ear shifts back in a 3/4 view.

Leave space between his chin and shoulder.

STEP 4

TIP
Draw a boy's hair as if he's two weeks overdue for a haircut.

The hair falls over his eyes, which gives him a casual, friendly look.

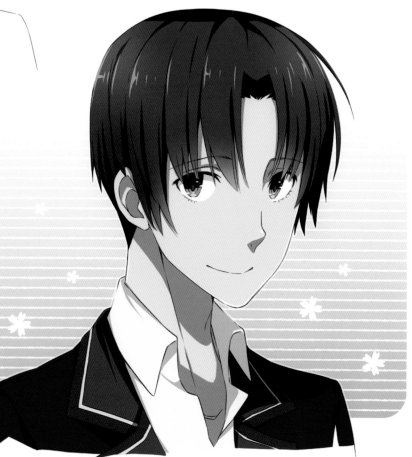

STEP 5

SIDE VIEW—GIRLS

The side view looks simple but can be tricky. Not to fear! We're going to add an extra step that will give you all the help you need along the way.

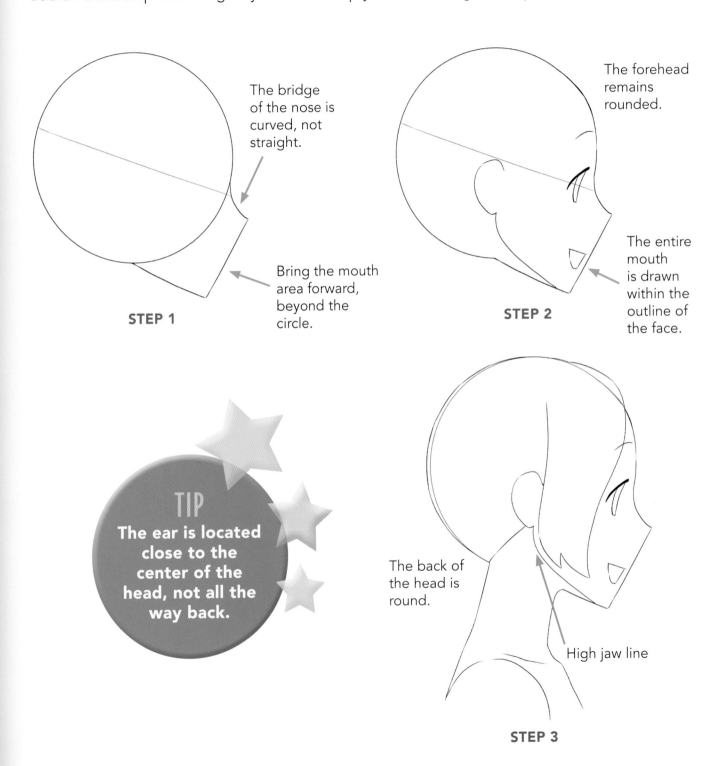

The bridge of the nose is curved, not straight.

Bring the mouth area forward, beyond the circle.

STEP 1

The forehead remains rounded.

The entire mouth is drawn within the outline of the face.

STEP 2

TIP
The ear is located close to the center of the head, not all the way back.

The back of the head is round.

High jaw line

STEP 3

THE FINISHING TOUCHES

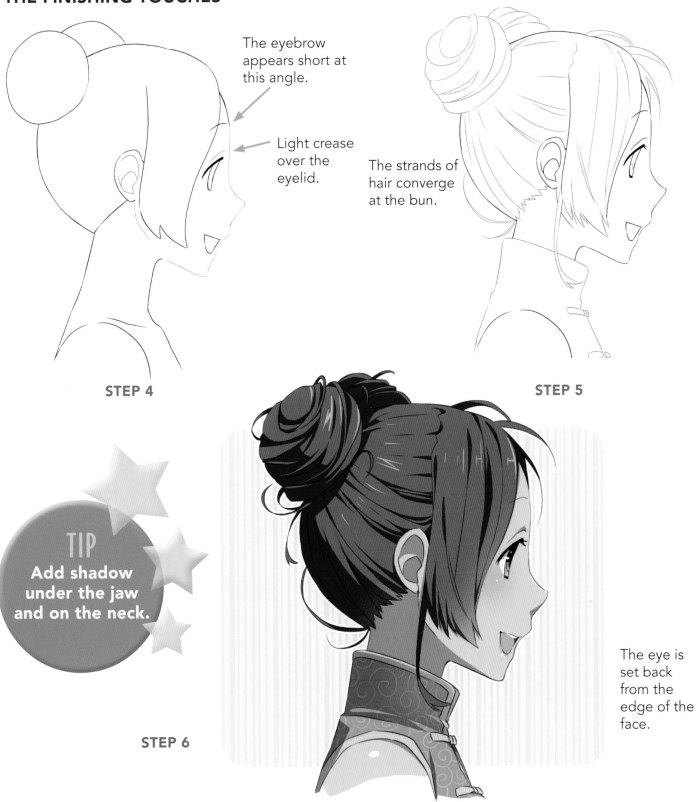

The eyebrow appears short at this angle.

Light crease over the eyelid.

STEP 4

The strands of hair converge at the bun.

STEP 5

TIP
Add shadow under the jaw and on the neck.

STEP 6

The eye is set back from the edge of the face.

25

SIDE VIEW—BOYS

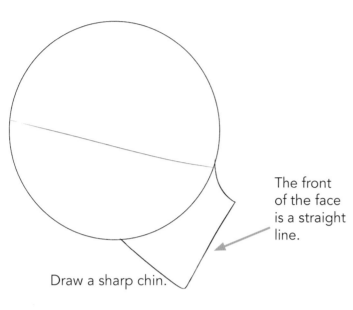

The front of the face is a straight line.

Draw a sharp chin.

STEP 1

TIP

Use a sharp "V" shape to create the chin.

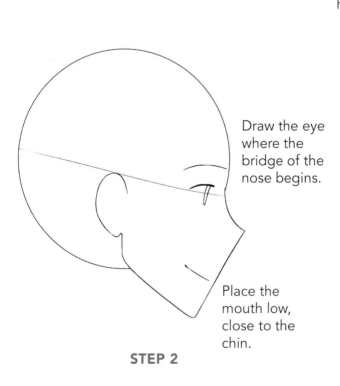

Draw the eye where the bridge of the nose begins.

Place the mouth low, close to the chin.

STEP 2

This popular hairstyle makes the back of the head look higher than it really is.

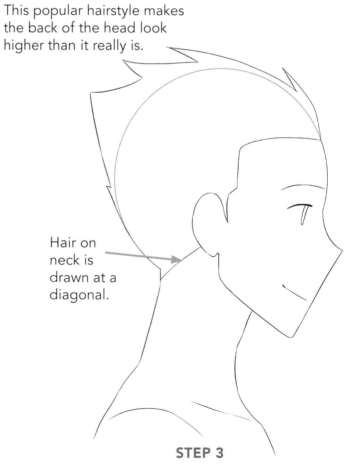

Hair on neck is drawn at a diagonal.

STEP 3

THE FINISHING TOUCHES

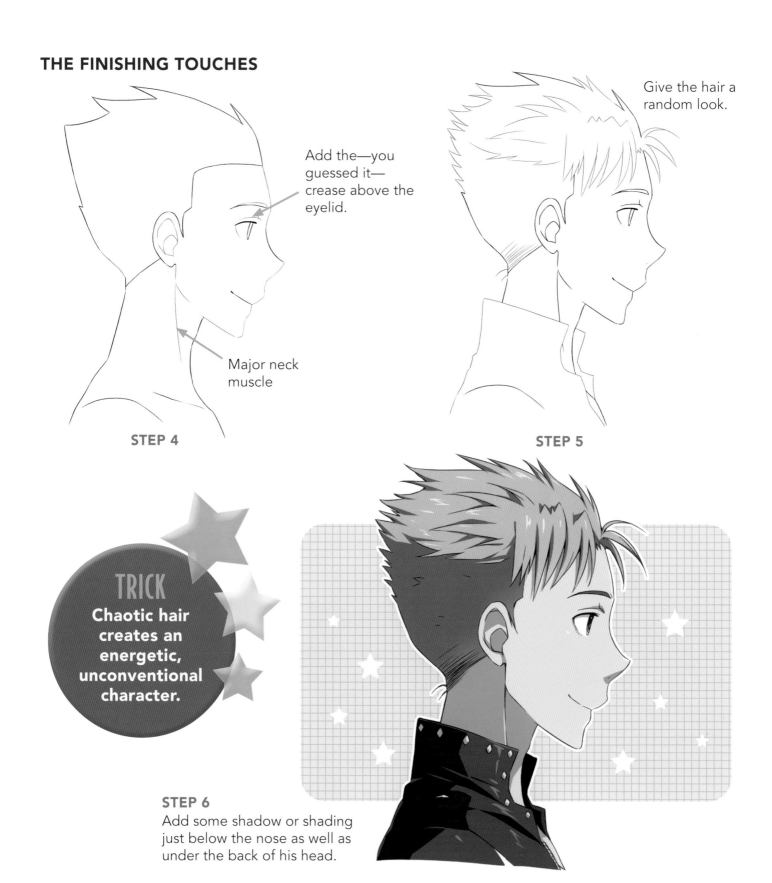

Add the—you guessed it—crease above the eyelid.

Major neck muscle

STEP 4

Give the hair a random look.

STEP 5

TRICK

Chaotic hair creates an energetic, unconventional character.

STEP 6
Add some shadow or shading just below the nose as well as under the back of his head.

Super-Simplified Expression Chart

Drawing expressions doesn't need to be complicated. The trick is to base them on one or two themes. For example, you can create a stunned look with small eyeballs and a wide-open mouth. If you draw those two things, you'll nail the expression. The rest is merely details.

Super angry

Thinking (Note the bead of sweat.)

Deadpan (humorous)

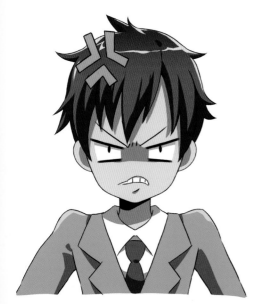

Positive reaction

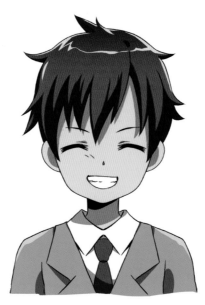

Happy

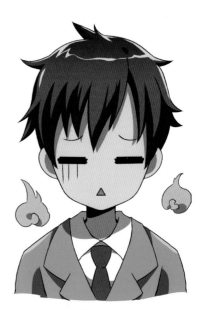

So sad

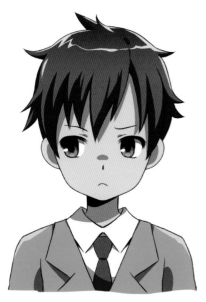

Apprehensive

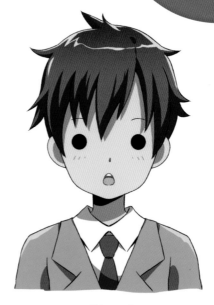

Oh no!

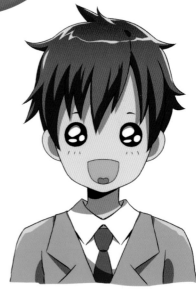

Such good fortune!

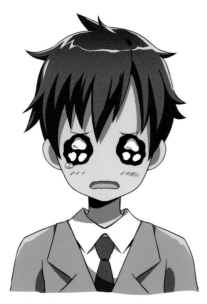

On the verge of a huge cry

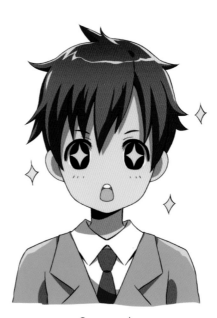

Stunned

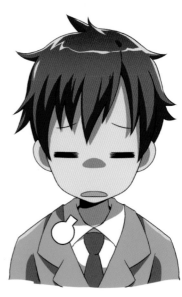

Ugh! I need a nap!

Troubleshooting Hairstyles

Here's the general tip: Don't "draw" hair, "design" a hairstyle. With a few practical hints, you'll be drawing stylish haircuts and greatly enhancing the look of your characters.

PIGTAILS (FAMOUS ANIME HAIRSTYLE)

The key to drawing pigtails is to raise them higher than the head.

The part starts at the back of the head.

TIP
Add ruffles of hair at the base of each pigtail.

Draw the hair in uneven clumps, for a natural look.

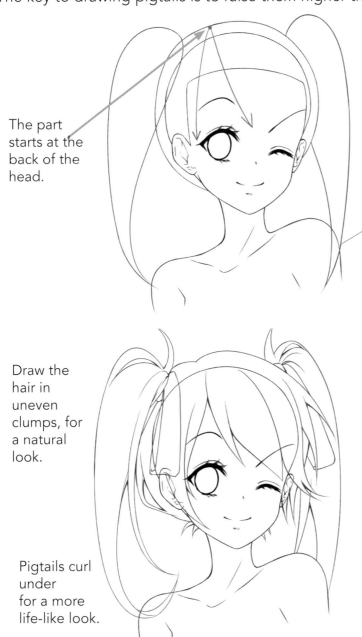

Pigtails curl under for a more life-like look.

Blend lighter areas of the hair with darker areas.

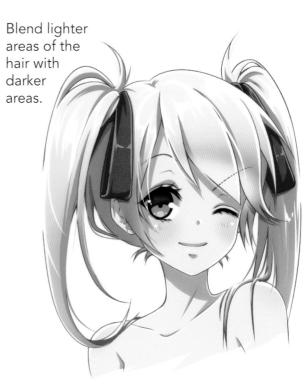

LONG WITH STRAIGHT BANGS (EXTRA CUTE)

This classic anime cut stays close to the head all around. There are three elements to this style: bangs straight across, long hair down the back, and side strands in front of the ears.

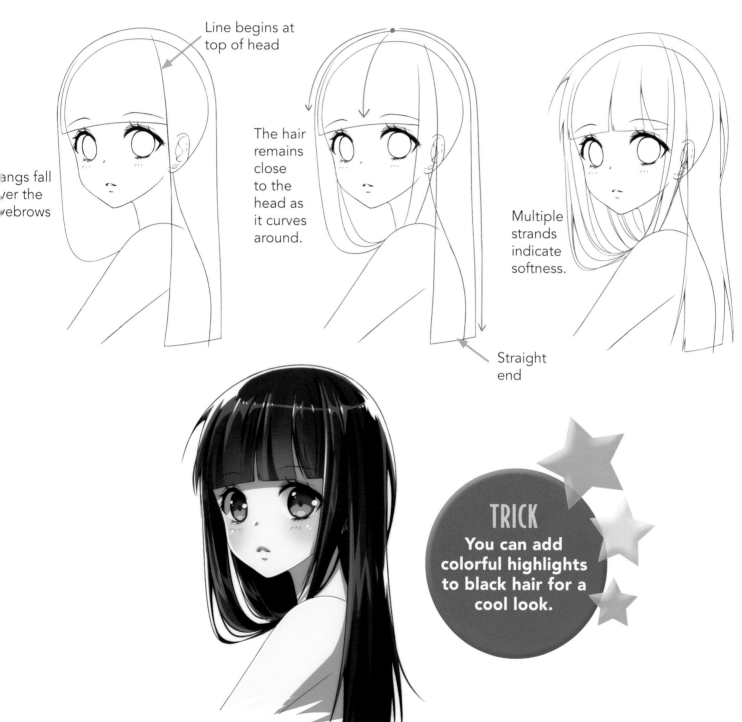

Line begins at top of head

angs fall
ver the
ebrows

The hair remains close to the head as it curves around.

Multiple strands indicate softness.

Straight end

TRICK
You can add colorful highlights to black hair for a cool look.

RANDOM FUN

Energetic characters are drawn with high-energy haircuts. It looks spontaneous, but there's actually a method for drawing it. Here's how to do it.

This hairdo is really just another version of the common flip.

The long strands curve toward the center of the collarbones.

Draw short, random tips at the bottom.

The long strands turn out at the ends.

Keep the eyebrows light. You should barely be able to see them.

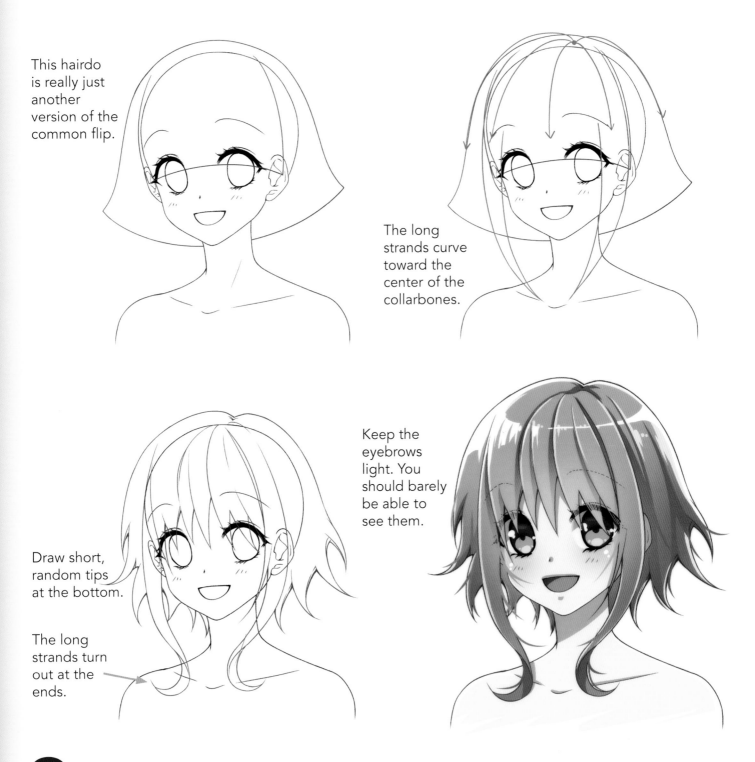

MORE HINTS—CLASSIC CUTS FOR GIRLS

Use any of these as a starting point for your character drawings.

TIP
Note that each face on this page is the same, but the character types appear very different.

Short and Sharp
For a slick look, draw a side part.

Braided Ponytail
A ponytail worn over the shoulder is a very popular variation.

Basic Schoolgirl
A headband with a bow indicates a proper student.

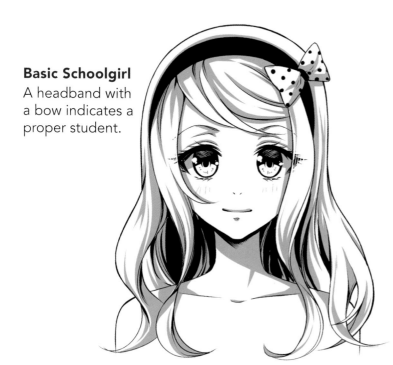

Choppy
This hairstyle suggests an adventurous type.

Modern Hairstyles—Boys

Creating a cool hairstyle is as important for guy characters as it is for girl characters. If you've been to an anime convention, you know what I mean. Different hair can create a totally different character type.

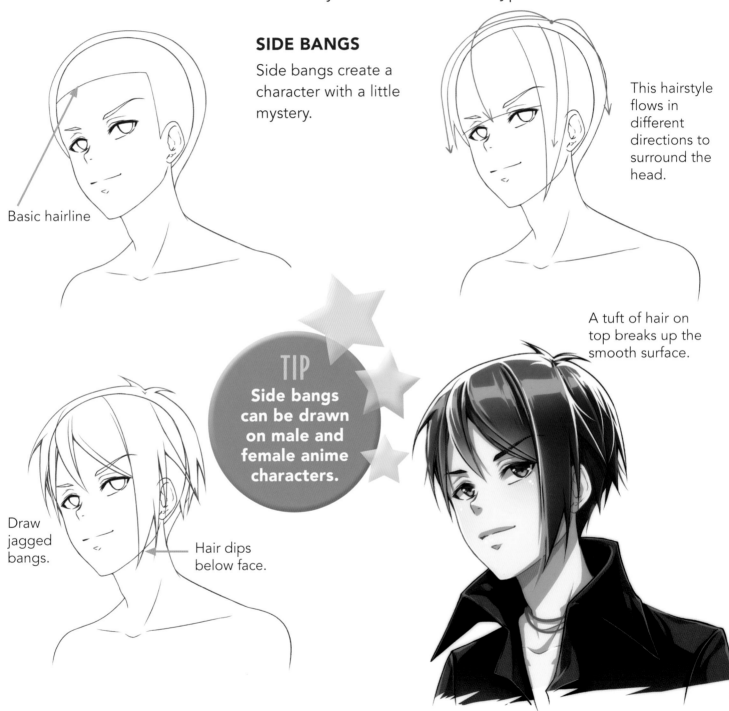

SIDE BANGS

Side bangs create a character with a little mystery.

Basic hairline

This hairstyle flows in different directions to surround the head.

A tuft of hair on top breaks up the smooth surface.

TIP
Side bangs can be drawn on male and female anime characters.

Draw jagged bangs.

Hair dips below face.

UNCOMBED

All boys look like this just before their mothers yank them back inside and orders them to comb their hair. Once it's nice and neat, they send him off to school. Five minutes later, his hair looks nuts again. Not that I would know.

TIP

By indicating the hairline, you create a good foundation for your hairstyle.

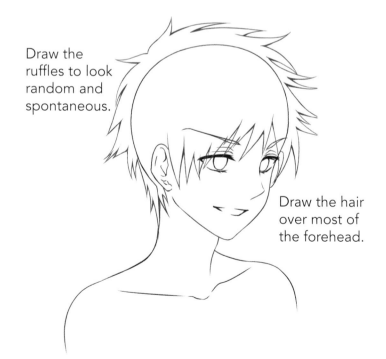

Top hairline

Side hairline

The hair spins out from a central point.

Draw the ruffles to look random and spontaneous.

Draw the hair over most of the forehead.

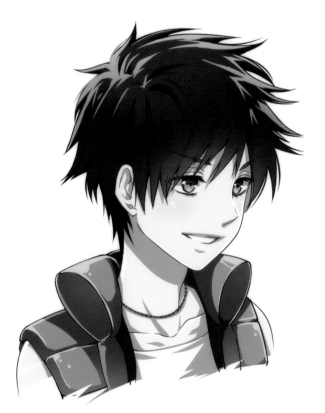

SHORT (CHOPPED)

Short hair isn't really all that short on most anime characters. It's only shorter than other hairstyles. The hair still falls below the character's eyes. This is a cute cut, similar to the female bob. It's often seen on young characters.

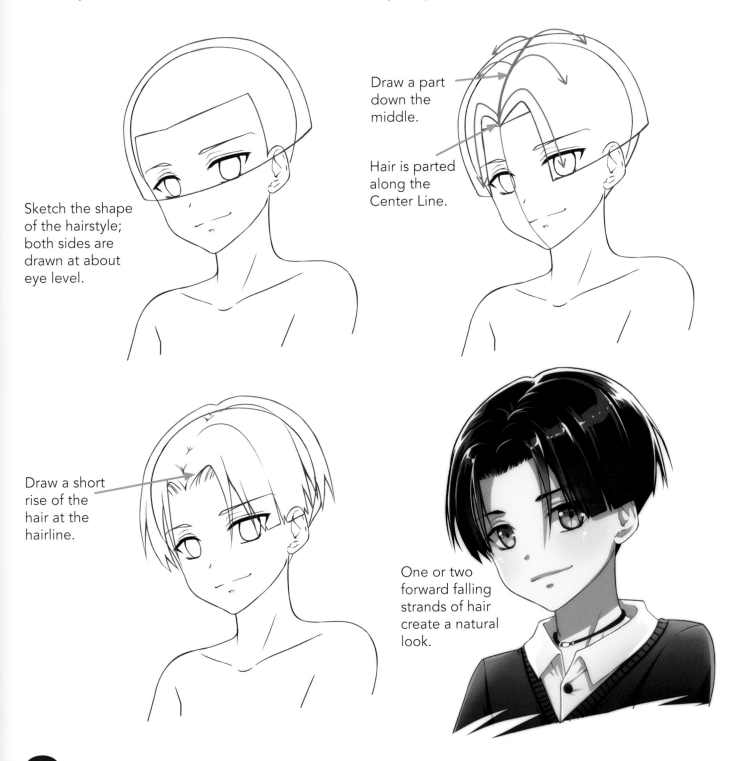

Draw a part down the middle.

Hair is parted along the Center Line.

Sketch the shape of the hairstyle; both sides are drawn at about eye level.

Draw a short rise of the hair at the hairline.

One or two forward falling strands of hair create a natural look.

MORE HINTS—CLASSIC CUTS FOR BOYS

Use any of these as a starting point for your character drawings.

TIP Some hairstyles don't need a part at all.

Extreme Layering
Draw tufts of hair upon tufts of hair for a highly popular anime look.

Closely Cropped
The hair is drawn close to the head, as if it were painted on.

Side Sweep
This style is based on a severe sweep to the right, with the hair extending past the head.

Random—No Part When you draw floppy hair, you don't need a part. The hair surrounds the face.

Keys to Creating Character Types

The key to creating a character is to emphasize *one* main idea. Too many elements can get confusing. Let's see how streamlining a concept works.

THE BEST FRIEND
This friendly type has bright eyes, an easy going smile, and casual clothes.

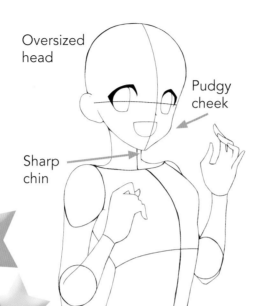

Oversized head

Pudgy cheek

Sharp chin

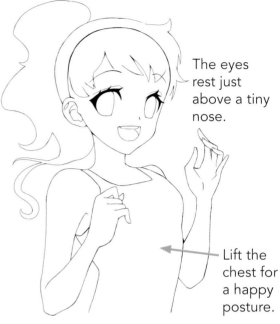

The eyes rest just above a tiny nose.

Lift the chest for a happy posture.

TRICK
Original characters are created by making a series of minor tweaks, not giant changes.

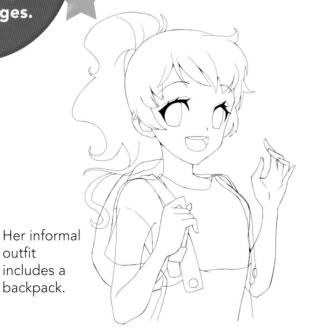

Her informal outfit includes a backpack.

38

ANNOYINGLY CHEERFUL GIRL

She has an overabundance of happy energy. Just being around her for ten minutes is exhausting.

Head tilts back

The open eye is huge and dominates the face.

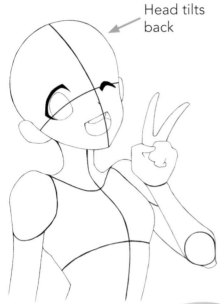

TIP

The hairstyle teeters between fun and ridiculous.

The wild hairdo creates an entirely new look—but how do you brush it?

TIP

Using a different color scheme helps to create unique characters.

Add ruffles, suspenders, and a bow.

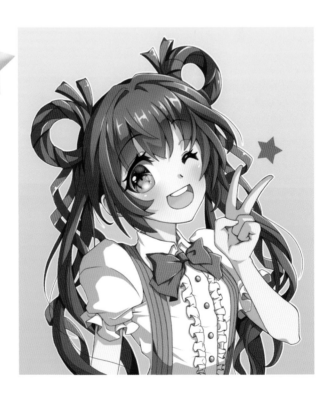

BASHFUL TYPE

Create a shy and precious personality by drawing oversized eyes and an introverted pose. Note, though, that her forehead has been exaggerated to look large, which is a young look.

TIP

Worried eyes combined with a smile create a bashful expression.

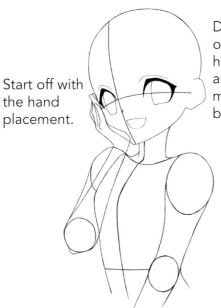

Start off with the hand placement.

Draw an oversized head on top and small mouth at the bottom.

Eyebrows tilt up

Draw the elbow close to the body.

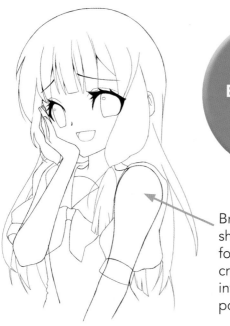

TIP

Be inventive with hair colors.

Bring this shoulder forward, creating an introverted pose.

QUICK-TEMPERED TYPE

This angry type is the opposite of relaxed. Tighten the expression and body language. (Do not get into an arguement with her!)

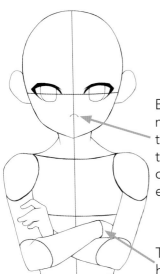

Bring the mouth higher than usual to form a disapproving expression.

Tuck the hand under the arm.

TRICK
Narrowing the eyes creates an angry expression.

Draw two flame-like pigtails—a visual metaphor for her hot temper.

The shoulders are wider than the elbows.

TIP
Pretty little bows are funny, given how angry she gets.

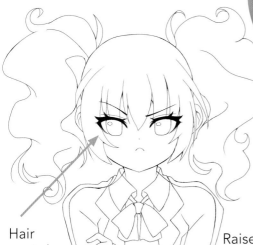

Hair encircles her face

Raise the shoulders up to create tension in this pose.

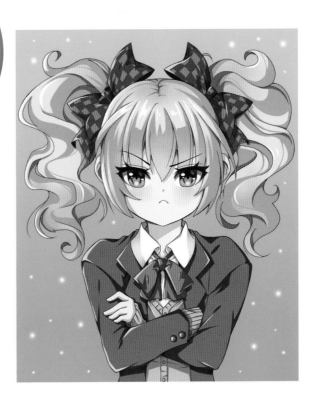

HONEST TYPE

This character is drawn with a wide face. Nice guys have wider faces than mean-spirited characters.

The top of the head is round, but the bottom is angular.

The eyes and ears are drawn high on the head.

The ears and hair make the face look wider than it actually is.

Draw a small smile for a pleasant expression.

TIP
Male characters have head shapes that are based on a tall oval.

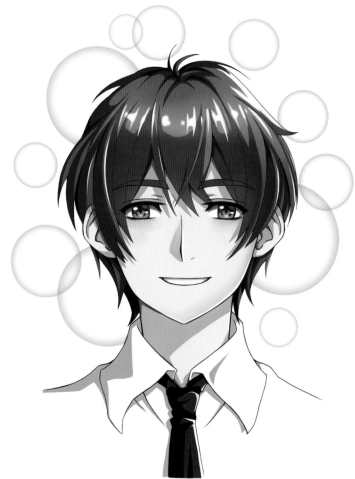

The round-faced guy has the look of a nice, good-natured boy. Next, we'll see what happens when we narrow the head shape.

DISHONEST TYPE

Morally questionable characters are drawn with a sharp and elongated head shape.

Draw the eyes closer together.

The head is much thinner than the previous character's.

The eyebrows are angled down.

You can injure someone with that pointy chin!

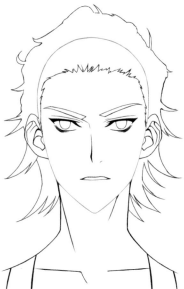

TIP
The outline of the eye is thick and dark on dishonest characters.

Sharp strands

He really needs to get that shirt pressed.

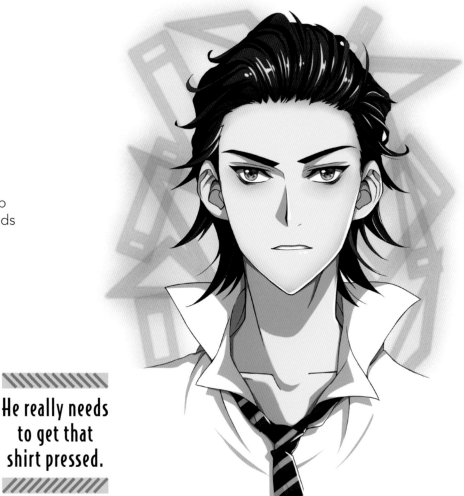

HANDSOME TYPE

Idealized features and hair create a dramatic look. It's important to draw them with a slightly bored expression.

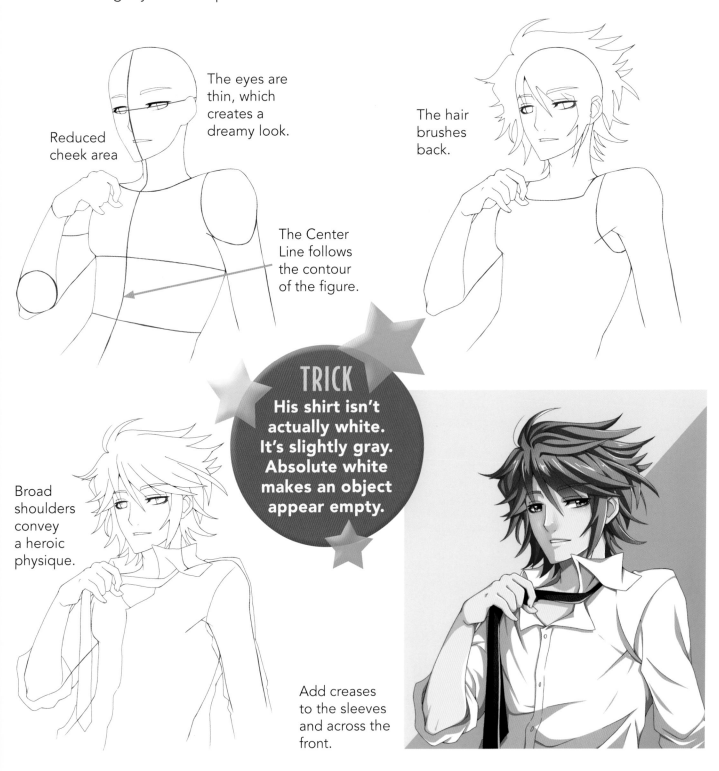

The eyes are thin, which creates a dreamy look.

Reduced cheek area

The hair brushes back.

The Center Line follows the contour of the figure.

TRICK

His shirt isn't actually white. It's slightly gray. Absolute white makes an object appear empty.

Broad shoulders convey a heroic physique.

Add creases to the sleeves and across the front.

GEEKY TYPE

Bright and goofy, with an energetic expression, this is a popular, funny character type. He must have selected that outfit with his eyes closed.

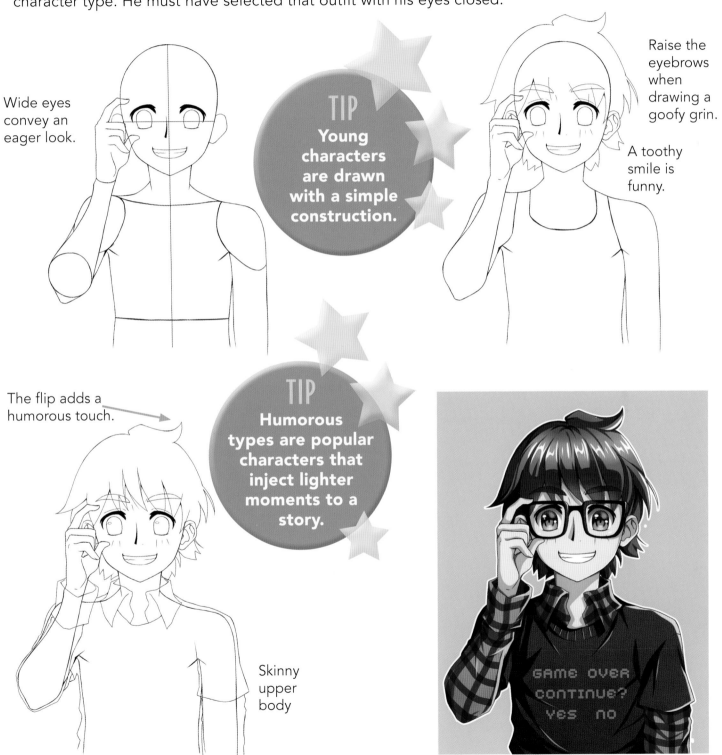

Wide eyes convey an eager look.

TIP Young characters are drawn with a simple construction.

Raise the eyebrows when drawing a goofy grin.

A toothy smile is funny.

The flip adds a humorous touch.

TIP Humorous types are popular characters that inject lighter moments to a story.

Skinny upper body

GAME OVER
CONTINUE?
YES NO

Character Types—You Decide!

Here are two appealing character types. You can tweak or change them anywhere along the way to create your own versions.

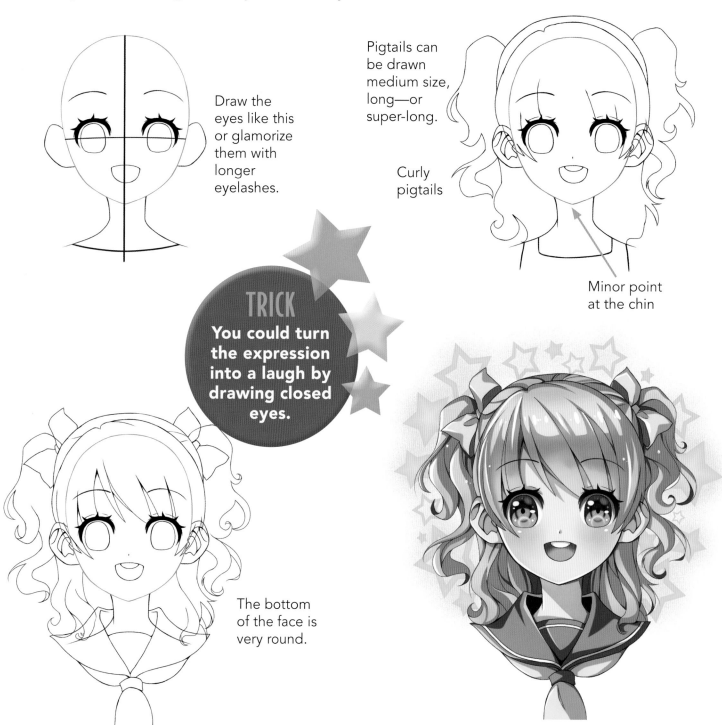

Draw the eyes like this or glamorize them with longer eyelashes.

Pigtails can be drawn medium size, long—or super-long.

Curly pigtails

Minor point at the chin

TRICK

You could turn the expression into a laugh by drawing closed eyes.

The bottom of the face is very round.

THIN FACE TYPE

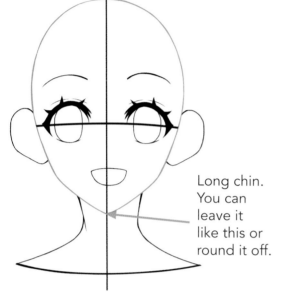

Long chin. You can leave it like this or round it off.

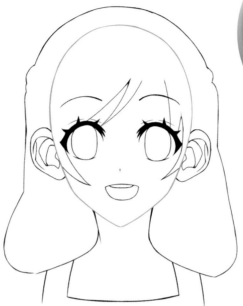

Draw glasses to give her an intellectual look.

Draw a few ribbons for an accent.

Variation: Draw a small "o," to create a surprised expression.

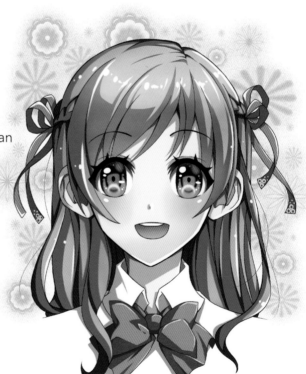

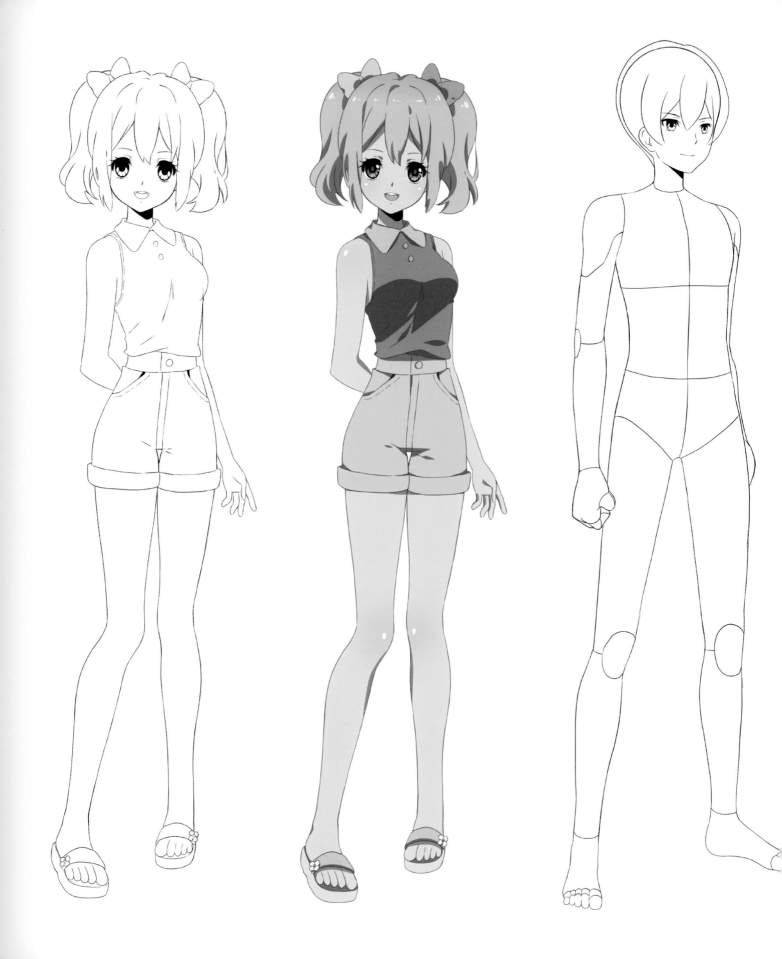

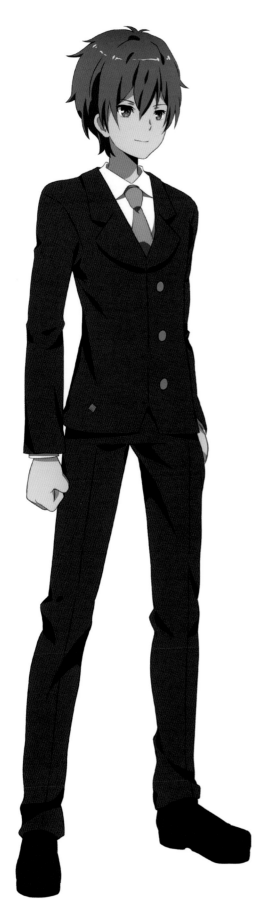

Basic Body Proportions

Using a few basic proportions, you can learn to draw bodies that look correct. *Proportions* simply means checking to make sure that things look like they're in the right place. Proportions are a great tool to use when a character you've drawn doesn't look quite right. A few adjustments to the proportions will fix it fast. This chapter will give you some useful tips to remember.

The Ultimate Proportions Tip

To maintain a consistant look to your character, maintain consistent proportions. Note the proportions as we draw the same character in a front, 3/4, and side pose.

TRICK

To break the symmetry of the pose, draw one hand in the pocket.

FRONT VIEW

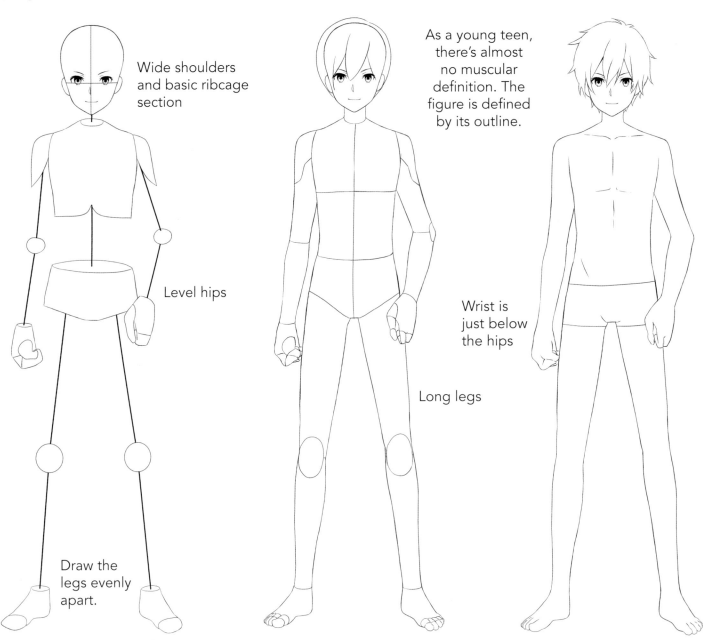

Wide shoulders and basic ribcage section

Level hips

Draw the legs evenly apart.

As a young teen, there's almost no muscular definition. The figure is defined by its outline.

Wrist is just below the hips

Long legs

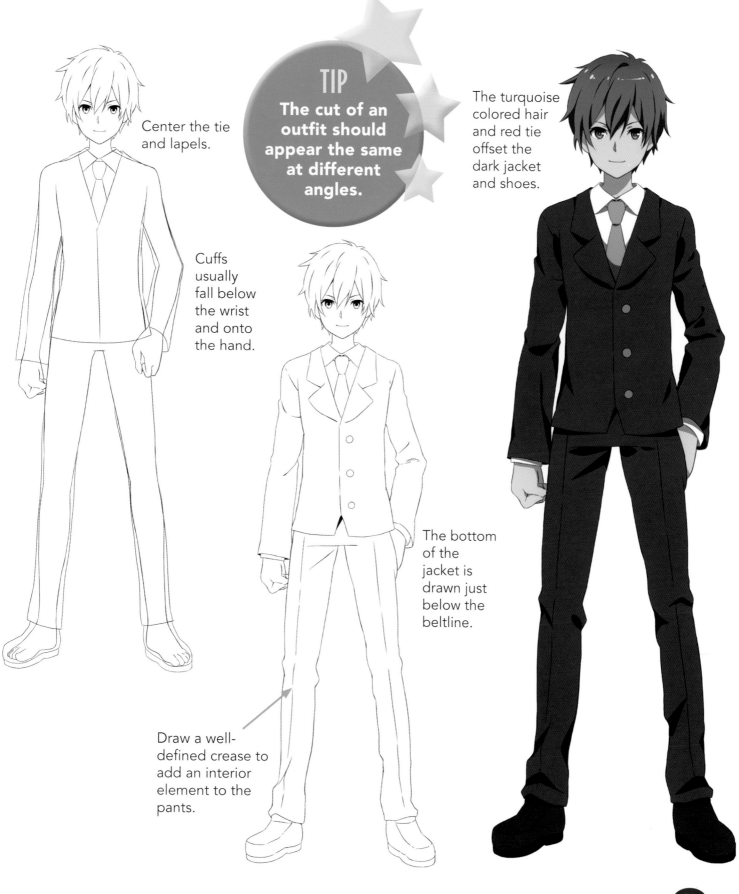

Center the tie and lapels.

TIP
The cut of an outfit should appear the same at different angles.

The turquoise colored hair and red tie offset the dark jacket and shoes.

Cuffs usually fall below the wrist and onto the hand.

The bottom of the jacket is drawn just below the beltline.

Draw a well-defined crease to add an interior element to the pants.

51

¾ VIEW

As you turn the boy character to the right, make sure his legs remain apart, as they did in the front view. That means that neither leg should appear directly below the Center Line of the body. (The Center Line still comes in handy!)

TIP

A basic construction is necessary, but it is only a starting point.

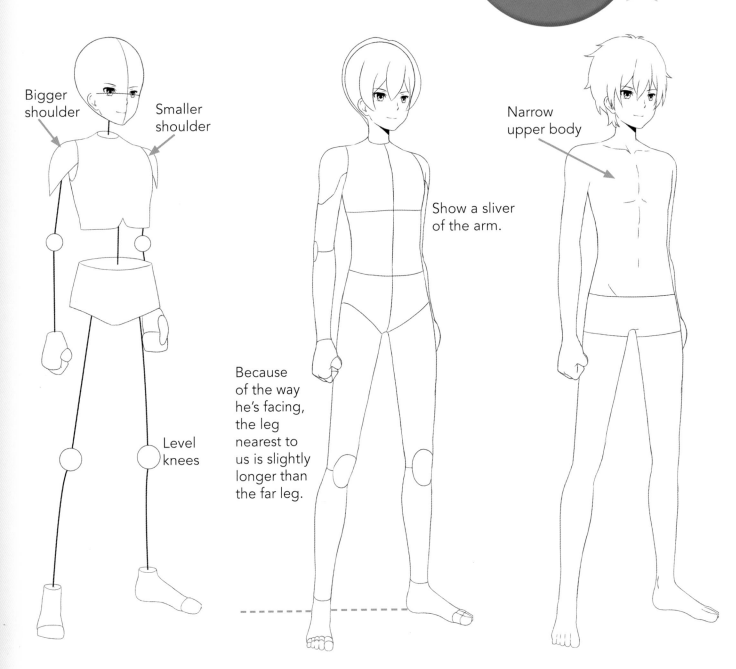

Bigger shoulder

Smaller shoulder

Level knees

Show a sliver of the arm.

Because of the way he's facing, the leg nearest to us is slightly longer than the far leg.

Narrow upper body

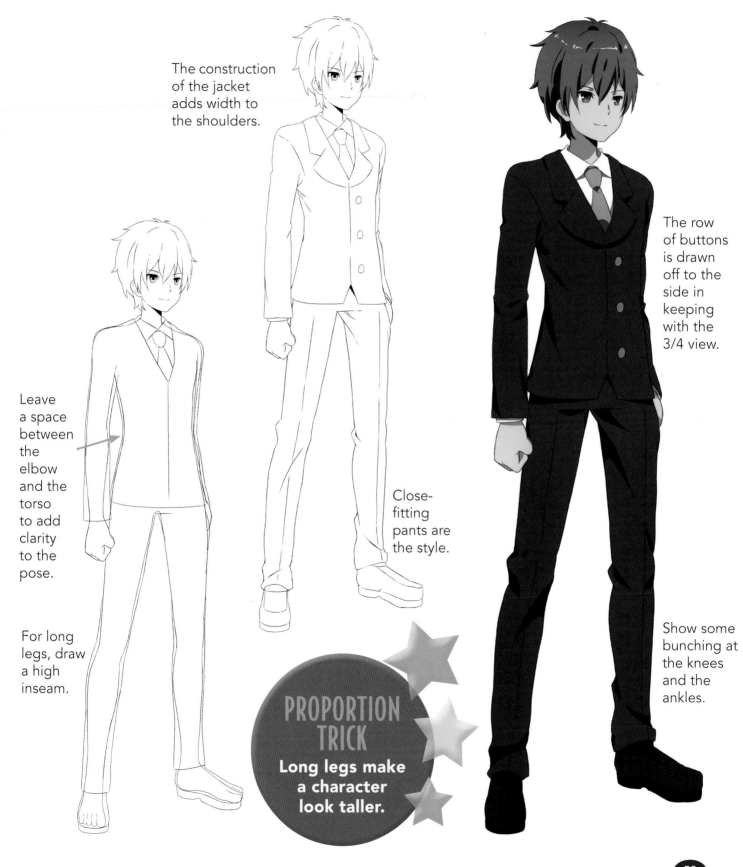

The construction of the jacket adds width to the shoulders.

Leave a space between the elbow and the torso to add clarity to the pose.

For long legs, draw a high inseam.

Close-fitting pants are the style.

The row of buttons is drawn off to the side in keeping with the 3/4 view.

Show some bunching at the knees and the ankles.

PROPORTION TRICK
Long legs make a character look taller.

SIDE VIEW

Here's a good trick for drawing the body in a side view: Draw the arm back to reveal more of the figure. This creates a cleaner-looking pose.

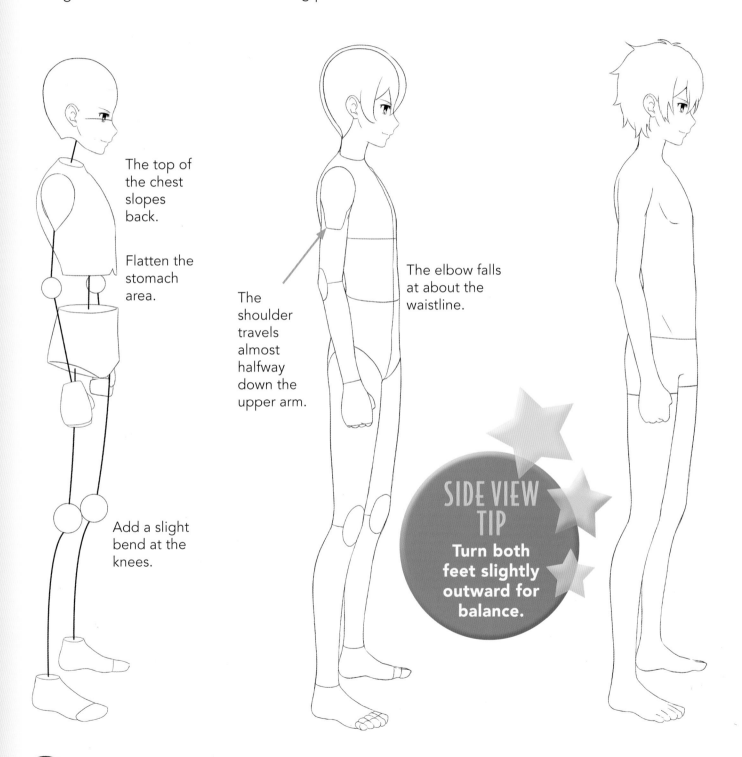

The top of the chest slopes back.

Flatten the stomach area.

The shoulder travels almost halfway down the upper arm.

The elbow falls at about the waistline.

Add a slight bend at the knees.

SIDE VIEW TIP

Turn both feet slightly outward for balance.

PROPORTION TIP

Here are 3 key proportions to keep in mind:
- The elbow appears halfway down the torso.
- The knee is at the midpoint of the leg, centered between the hips and the ankles.
- The wrist is at the level of the inseam.

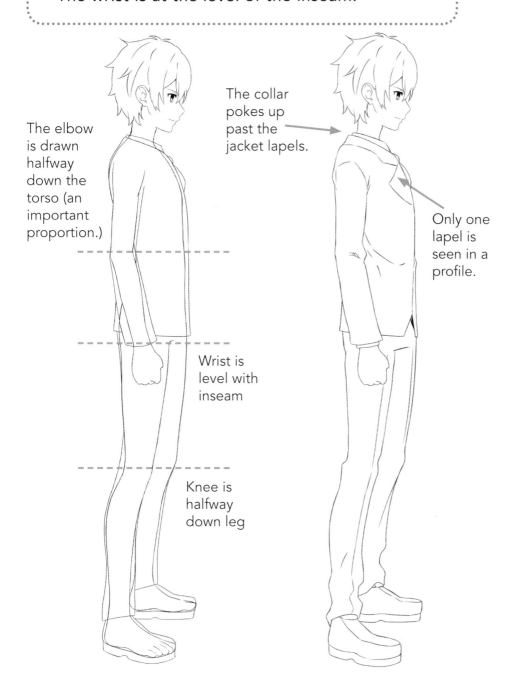

The elbow is drawn halfway down the torso (an important proportion.)

Wrist is level with inseam

Knee is halfway down leg

The collar pokes up past the jacket lapels.

Only one lapel is seen in a profile.

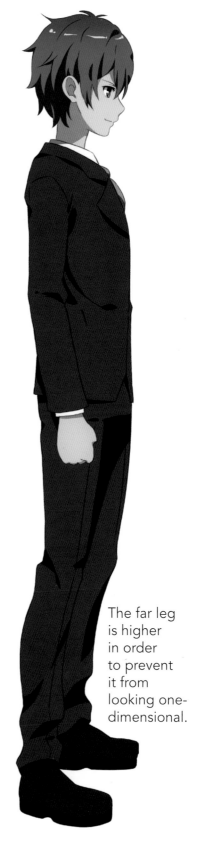

The far leg is higher in order to prevent it from looking one-dimensional.

Drawing a 180° Turn

Now that we've built a figure step by step in different angles, let's see what the finished process looks like. This is called a *turnaround*, and it is used by professional anime artists when developing a character for a show.

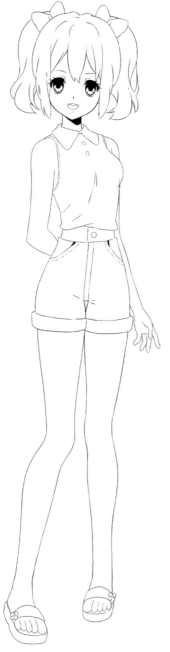

Front Pose

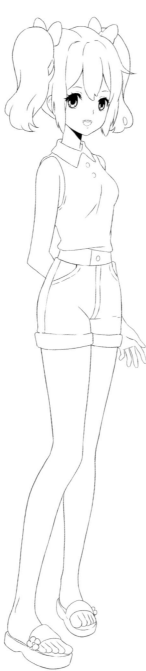

¾ Pose—Right

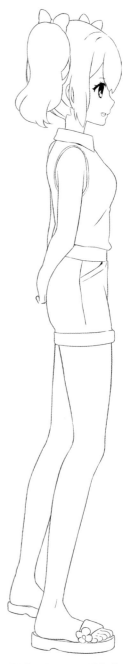

Side Pose—Right

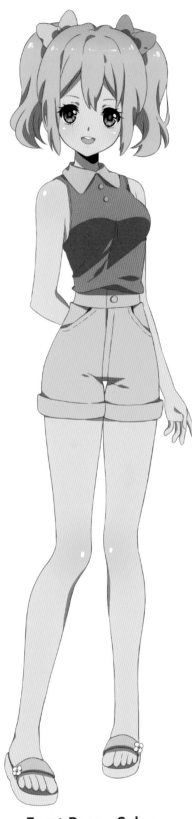

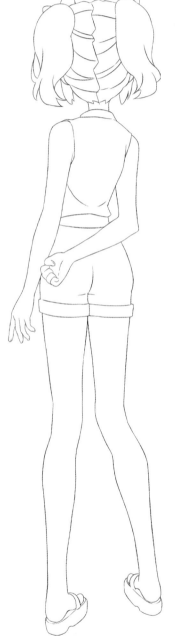

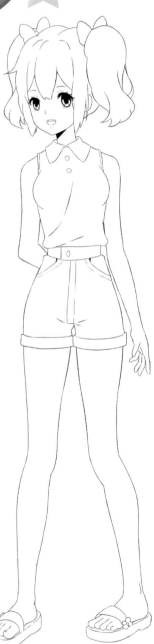

Back Pose

¾ Pose—Left

Front Pose—Color

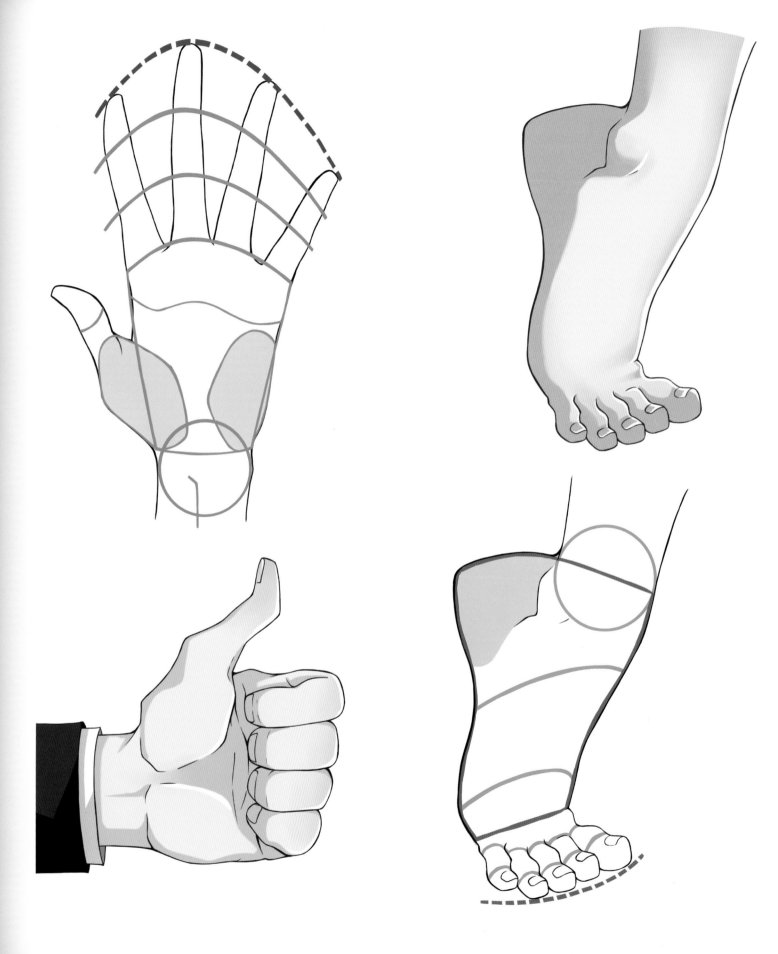

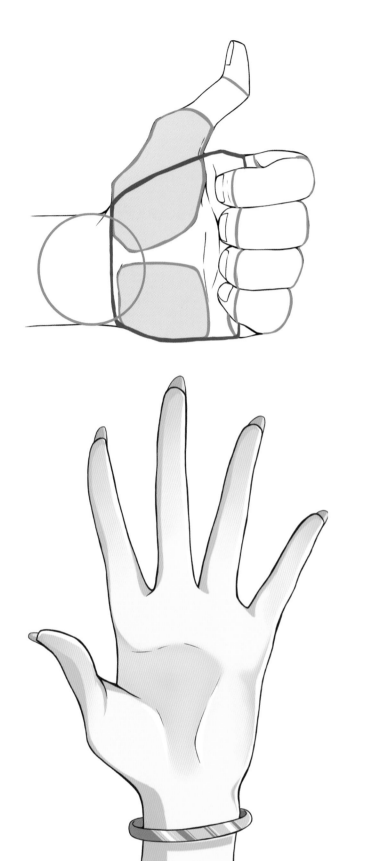

Drawing the Hands and Feet

Wouldn't it be wonderful if every character wore mittens? We'd never have to worry about drawing fingers or thumbs. Okay, back to earth. This chapter breaks down the essential elements of drawing hands and feet. The diagrams in this section are *concept drawings*: You don't need to draw them. Just by absorbing the basic concepts, you can improve your drawings.

Front of Hand

There are two considerations for drawing the palm side of the hand: its overall shape and the interior features. We'll look at both.

PALM—FINGERS TOGETHER

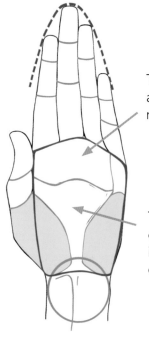

The palm "pyramids" at the base of the middle finger.

The center of the palm is slightly concave.

Darken the flat of the palm

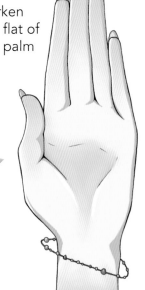

TIP

Don't make a character's fingernails too long or she'll look like a vampire.

PALM—FINGERS APART

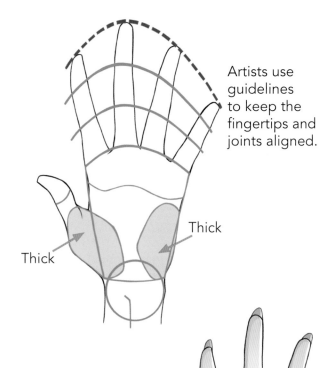

Artists use guidelines to keep the fingertips and joints aligned.

Thick

Thick

Thumbs vary in their ability to spread widely. Everyone is unique. But if everyone is unique, aren't we all the same? It's a paradox.

60

Back of the Hand

Accessories say a lot about a character. A teen wearing a skull ring has a different personality than one who wears a gold bracelet.

BACK OF HAND—FINGERS TOGETHER

BACK OF HAND—FINGERS APART

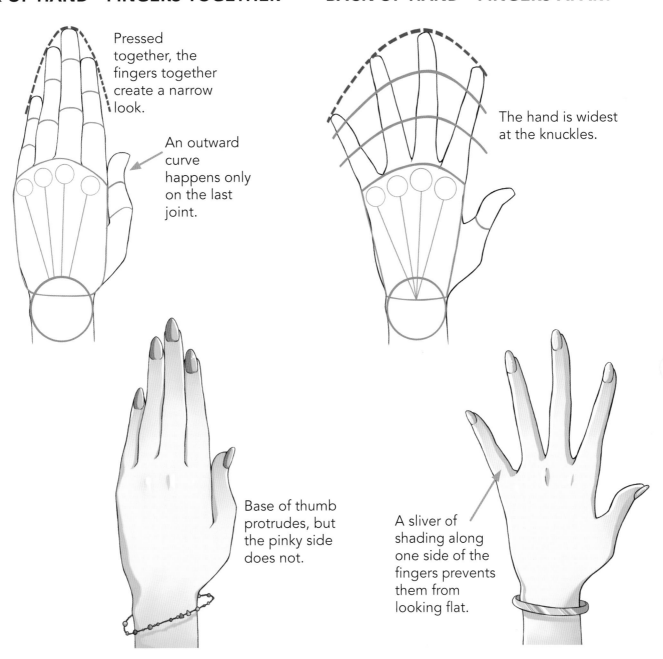

Pressed together, the fingers together create a narrow look.

An outward curve happens only on the last joint.

The hand is widest at the knuckles.

Base of thumb protrudes, but the pinky side does not.

A sliver of shading along one side of the fingers prevents them from looking flat.

Practical Hand Poses

We've seen the basic elements of the hand from the front and back. Now, let's use those principles to create the practical poses that are used in almost every anime show.

HOLDING A CUP

Vary the finger placement by adding a little space between each one.

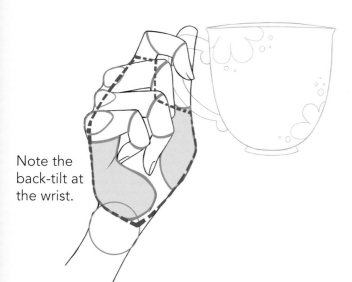

Note the back-tilt at the wrist.

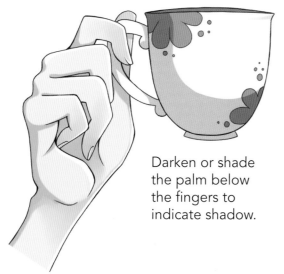

Darken or shade the palm below the fingers to indicate shadow.

FIST

This pose can be used for many things: a fist bump, a punch, or clenched in frustration while taking the SAT's.

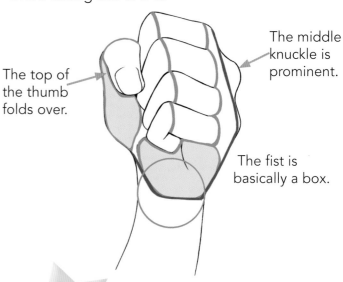

The top of the thumb folds over.

The middle knuckle is prominent.

The fist is basically a box.

TIP
The thumb is the key to any holding or grasping pose.

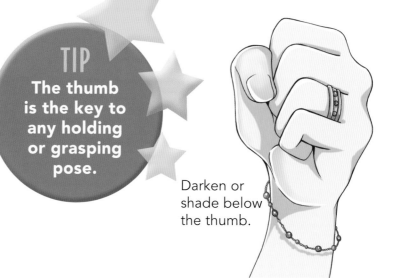

Darken or shade below the thumb.

HOLDING A PENCIL

Many people have trouble with this hand pose. Here's the trick: Draw the pencil first. As you draw, do not reposition the pencil in order to accommodate the hand. Instead, change the position of the hand to accommodate the position of the pencil.

TRICK
The trick to drawing a hand holding an object is to draw the object first, then draw the hand around it.

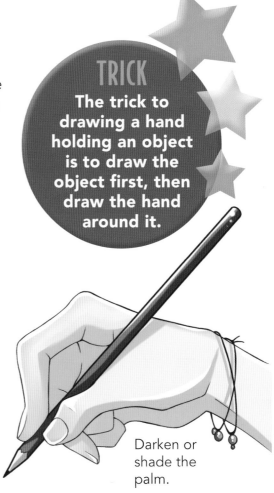

Each of the three joints of the index finger is bent.

The pencil rests in the crook of the hand between thumb and index finger.

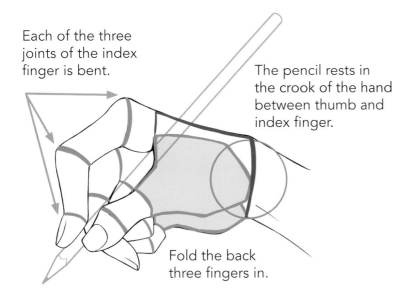

Fold the back three fingers in.

Darken or shade the palm.

PETTING

Because the side angle is flat, create interest by varying the placement of the fingers.

Middle finger protrudes

Bend wrist.

Darken or shade back fingers.

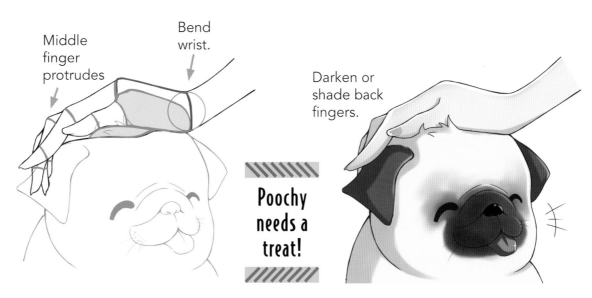

Poochy needs a treat!

Hand Signals

Many popular poses are built around hand signals. These convey an idea as clearly as the spoken word.

SIGN OF APPROVAL

Draw the extended fingers along a sloping guideline.

Only the tip of the index finger and the tip of the thumb touch.

Darken or shade the rest of the palm and edge of the fingers.

POINTING OUT!

The middle knuckle rises prominently.

The ring and middle fingers angle forward.

The bottom joint of the thumb is prominent.

The pinky is curled tightly.

Darken or shade the thumb and the thumb heel.

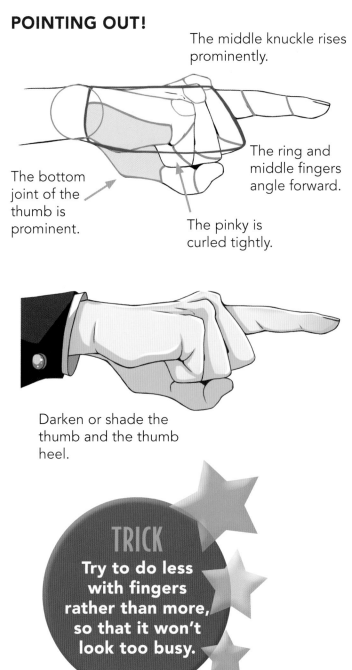

TRICK
Try to do less with fingers rather than more, so that it won't look too busy.

WE WON!

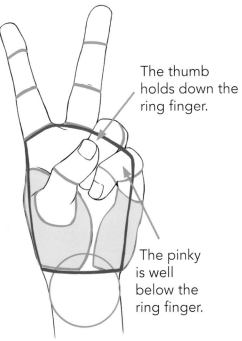

The thumb holds down the ring finger.

The pinky is well below the ring finger.

GOOD TO GO

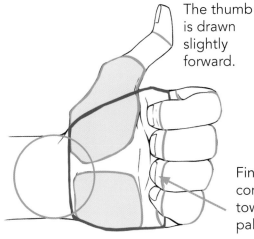

The thumb is drawn slightly forward.

Fingertips converge toward the palm

Add shading to the right side of fingers and palm.

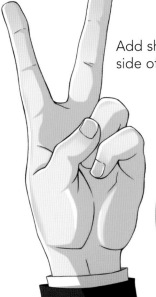

Darken or shade the fingertips and palm.

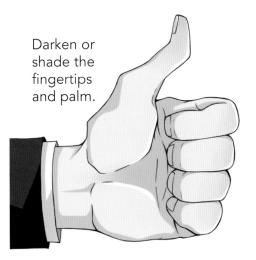

Drawing Feet—Examples and Angles

To draw feet, some beginners focus on the toes. But that's not where the basic construction is. It lies in the overall shape of the foot, which we'll break down into simple sections. Let's identify the components of the foot in common angles.

FRONT VIEW

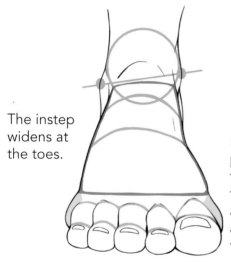

The instep widens at the toes.

Extra padding on the side of the big toe and little toe adds width to the foot.

UNDERSIDE

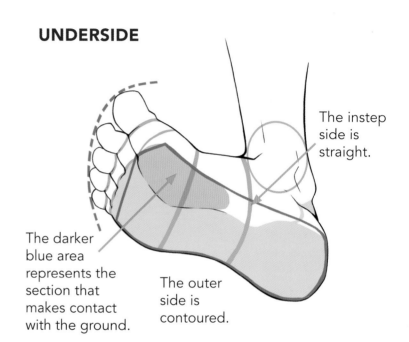

The instep side is straight.

The darker blue area represents the section that makes contact with the ground.

The outer side is contoured.

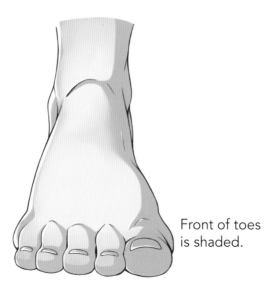

Front of toes is shaded.

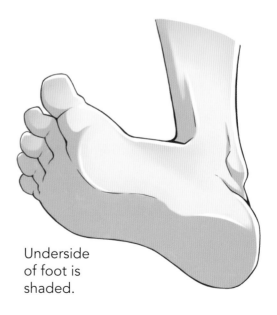

Underside of foot is shaded.

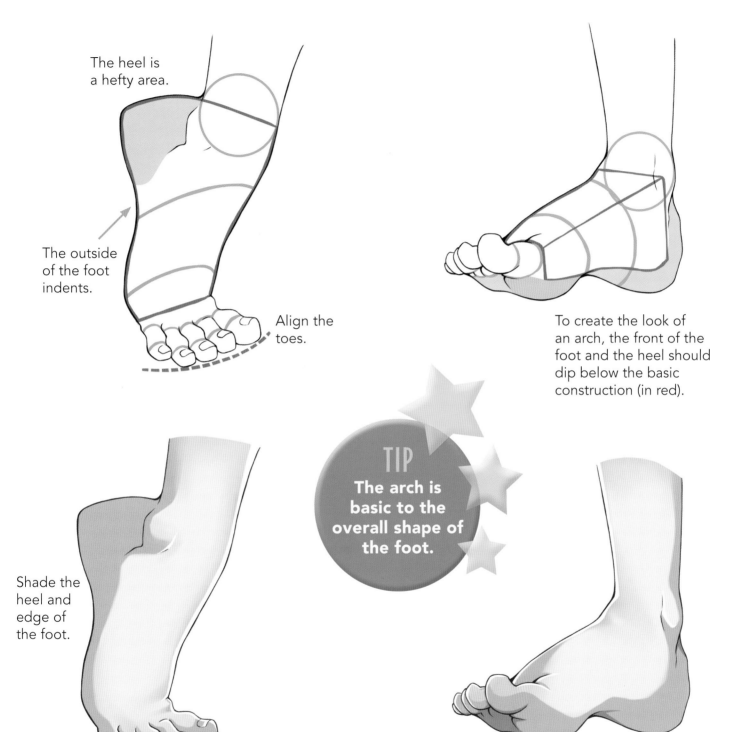

The heel is a hefty area.

The outside of the foot indents.

Align the toes.

To create the look of an arch, the front of the foot and the heel should dip below the basic construction (in red).

TIP

The arch is basic to the overall shape of the foot.

Shade the heel and edge of the foot.

Shade on either side of the arch.

TOPSIDE

This is an uncommon angle, but it's good to be familiar with it because it completes the concept.

Show a sliver of the heel, to give the appearance of depth.

The tallest point for the base of the toes

3/4 BACK ANGLE

Some people have trouble with the 3/4 rear angle, but it's easy once you know the techniques.

The foot is severely shortened at this angle.

Show the Achilles tendon.

The heel widens at the bottom.

Show a hint of the small toe.

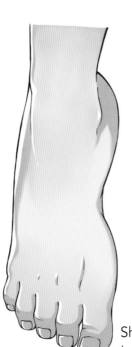

Shade bottom of toes and heel.

TIP

At the back angle, there is a severe slope from the bridge of the foot to the toes.

Shade heel, but leave a highlight on one side.

BOTTOM SIDE—ANGLE

SIDE ANGLE

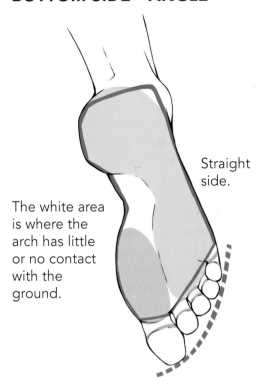

The white area is where the arch has little or no contact with the ground.

Straight side.

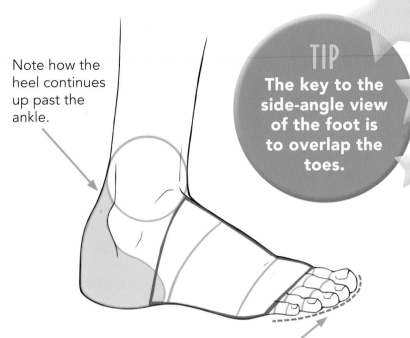

Note how the heel continues up past the ankle.

Each line overlaps the one behind it.

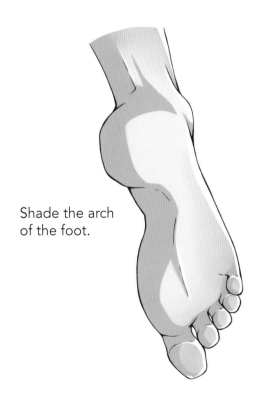

Shade the arch of the foot.

Add shading to the heel.

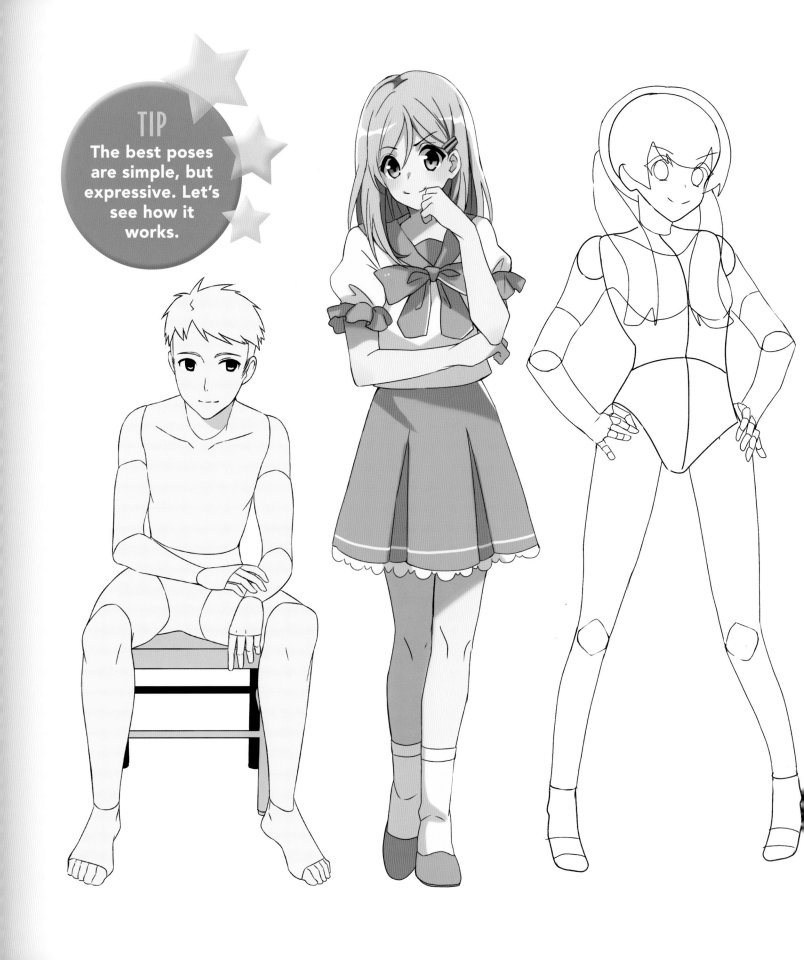

TIP

The best poses are simple, but expressive. Let's see how it works.

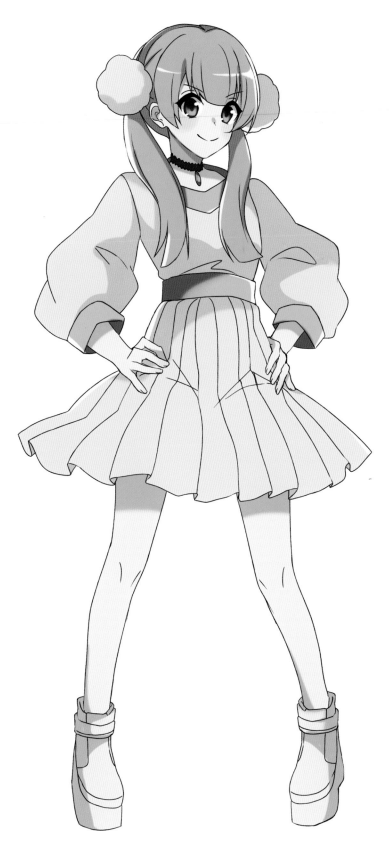

Keys to Drawing Poses

Poses communicate a character's attitude.
As an anime artist, most of the characters you draw will assume standing poses. By adding a few simple touches, you can transform an ordinary standing pose into one that is energetic and engaging. A simple bend of the knee, a tilt of the head, and a new pose is formed. You'll want to use a variety of poses to convey different emotions and intentions. Once we conquer the standing pose, we'll move on to sitting and reclining poses.

Standing Poses

The great misconception about standing poses is that they are drawn straight up and down. This causes some artists to flatten out the contours of the figure, when the curves should actually be highlighted. Even if a character has good posture, the body still has curves.

VARYING THE LEG PLACEMENT

To create variety in a pose, bend one leg just a little. That small change is enough to give the pose a natural, relaxed look.

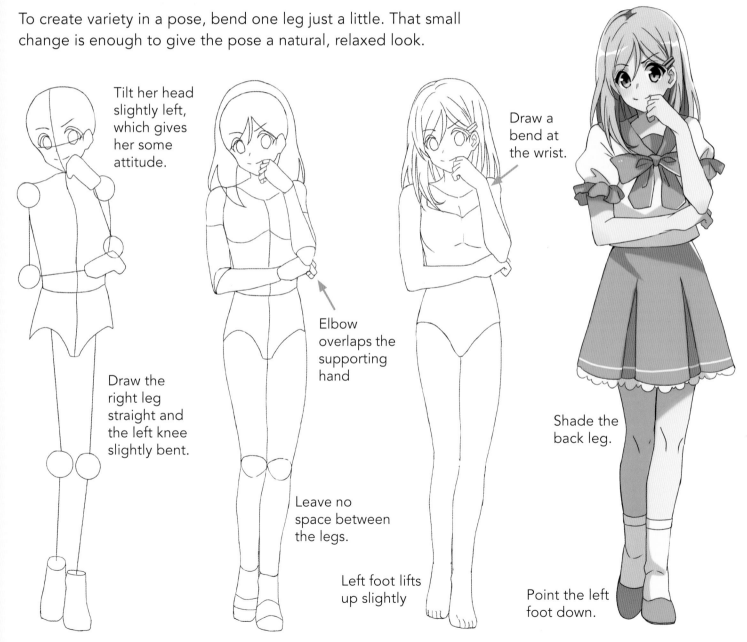

Tilt her head slightly left, which gives her some attitude.

Draw the right leg straight and the left knee slightly bent.

Elbow overlaps the supporting hand

Leave no space between the legs.

Draw a bend at the wrist.

Left foot lifts up slightly

Shade the back leg.

Point the left foot down.

LEGS SPACED EVENLY APART

When the legs are positioned wider apart than the shoulders, it signals confidence, even stubbornness. This stand-your-ground pose lets the viewer know that this character means business.

TIP
Wide, symmetrical foot placement creates a sturdy pose.

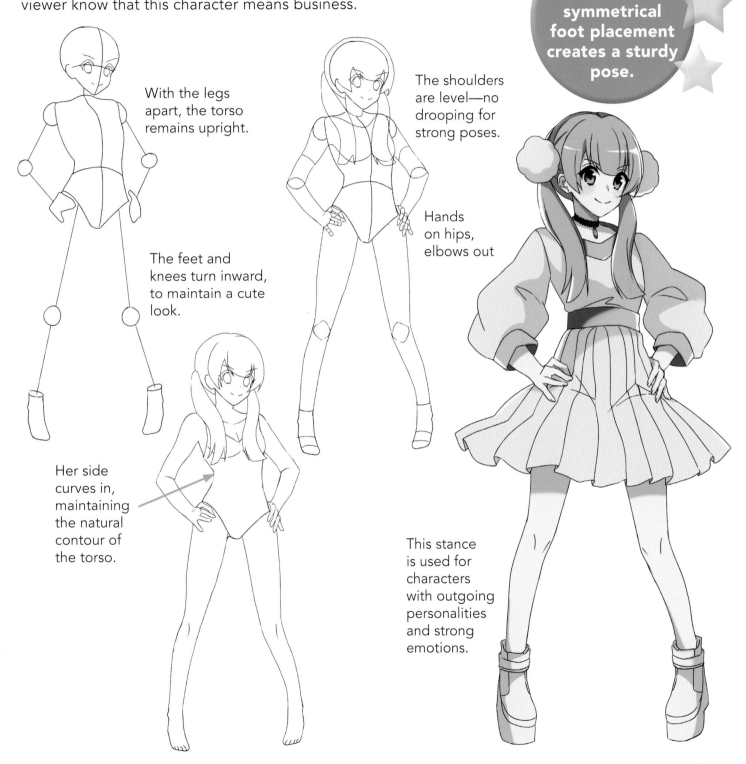

With the legs apart, the torso remains upright.

The feet and knees turn inward, to maintain a cute look.

The shoulders are level—no drooping for strong poses.

Hands on hips, elbows out

Her side curves in, maintaining the natural contour of the torso.

This stance is used for characters with outgoing personalities and strong emotions.

HANDS IN POCKETS

This is a famous pose that we see all the time. This pose is a good choice for characters who are watching something or listening to a friend. It's super-casual.

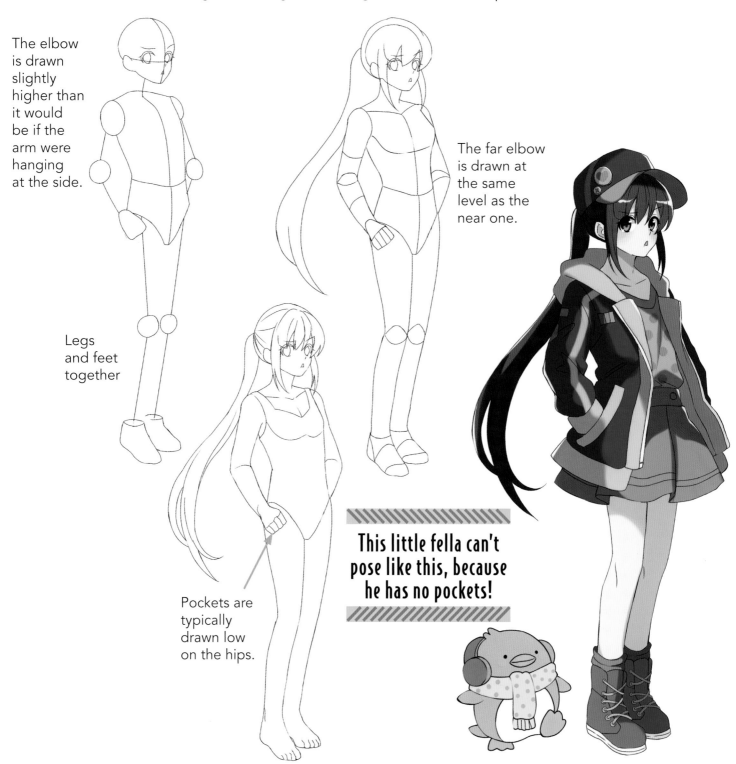

The elbow is drawn slightly higher than it would be if the arm were hanging at the side.

Legs and feet together

The far elbow is drawn at the same level as the near one.

Pockets are typically drawn low on the hips.

This little fella can't pose like this, because he has no pockets!

STYLISH POSE

When a fashionable character strikes a stylish pose she turns to face the camera or viewer.

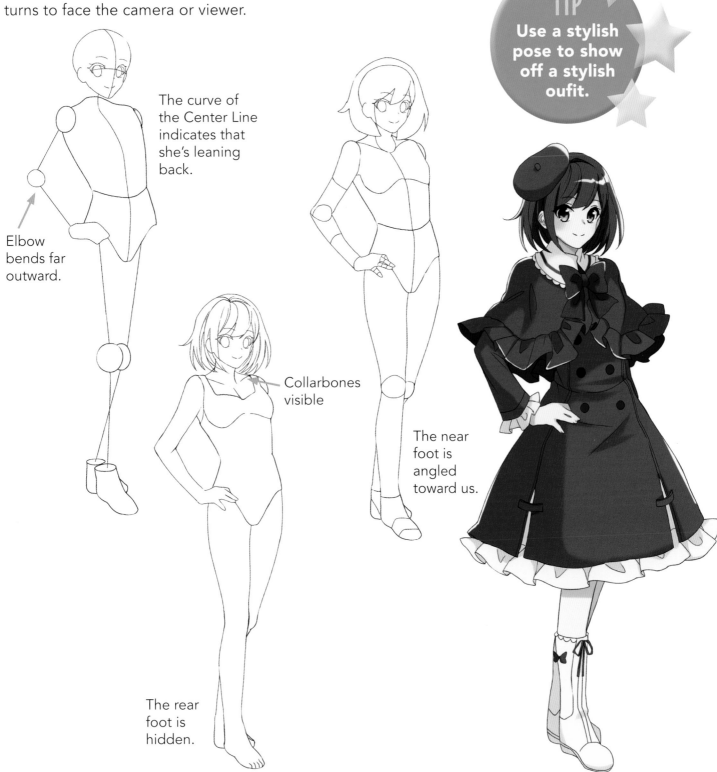

The curve of the Center Line indicates that she's leaning back.

Elbow bends far outward.

Collarbones visible

The near foot is angled toward us.

The rear foot is hidden.

TIP

Use a stylish pose to show off a stylish outfit.

Sitting and Reclining Poses—Important Tips

Rarely do you see sitting poses covered in depth in an art instruction book. And yet, teens sit everywhere: on the floor, in school hallways, in fast food restaurants, on amusement park rides, and in the bleachers during sports events. You also see teens in reclining poses at the beach or on their bed while doing homework.

SITTING ON A CHAIR

Sitting characters lean forward and bend slightly at the waistline. They rest their arms on their legs.

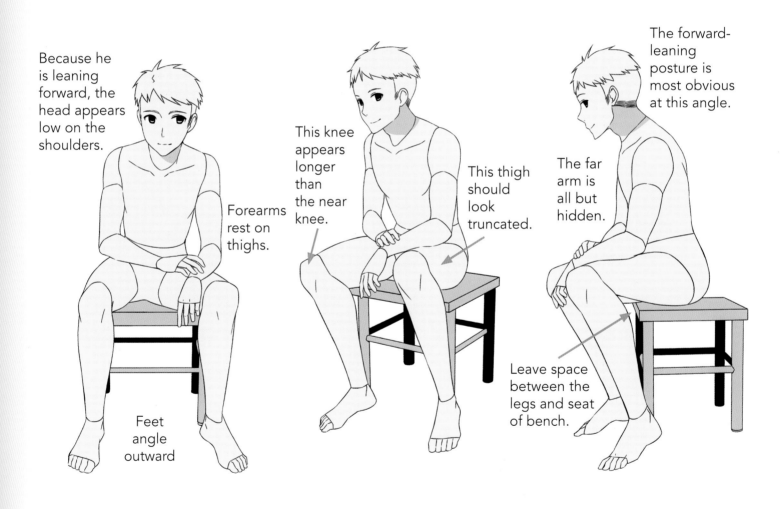

Because he is leaning forward, the head appears low on the shoulders.

Forearms rest on thighs.

Feet angle outward

This knee appears longer than the near knee.

This thigh should look truncated.

The forward-leaning posture is most obvious at this angle.

The far arm is all but hidden.

Leave space between the legs and seat of bench.

Front View

¾ View

Side View

SITTING CROSS-LEGGED ON THE GROUND

Here we run into a common problem: where to cross the legs. The legs should appear to cross at the ankles. The knees must also come off the ground. Now let's look at the specifics.

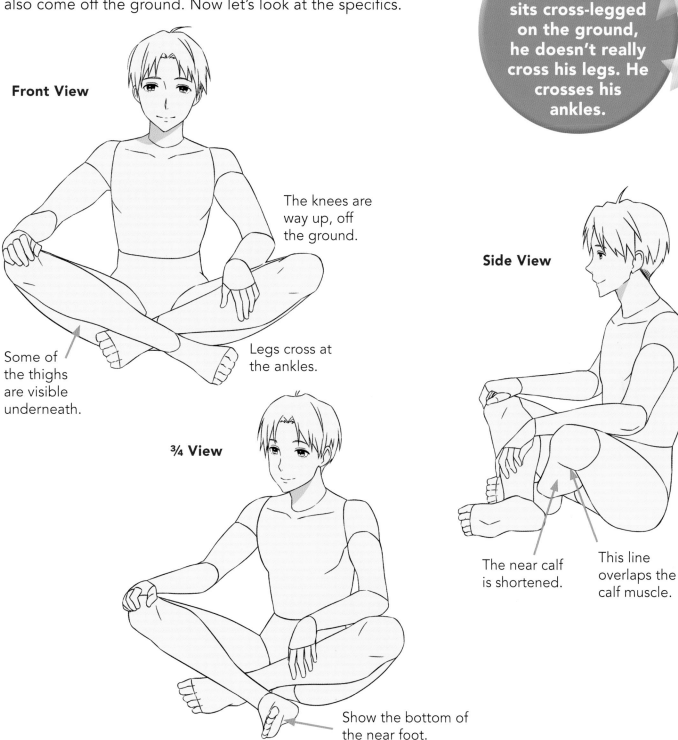

TIP

When a character sits cross-legged on the ground, he doesn't really cross his legs. He crosses his ankles.

Front View

The knees are way up, off the ground.

Some of the thighs are visible underneath.

Legs cross at the ankles.

¾ View

Show the bottom of the near foot.

Side View

The near calf is shortened.

This line overlaps the calf muscle.

77

KNEELING POSE

Just thinking of sitting in this position gives me torn ligaments. And yet, it's a popular pose. So let's draw it! It's easier than you might think. To draw, that is.

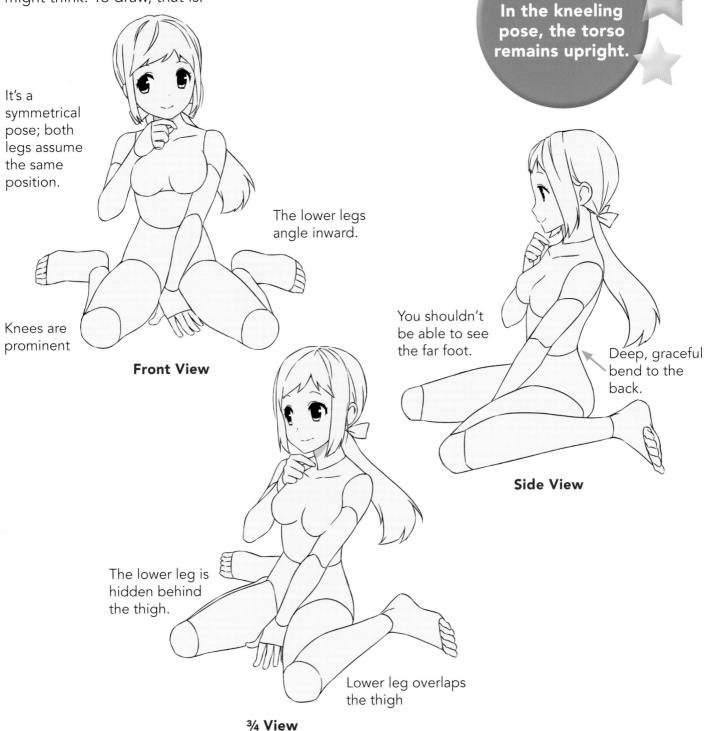

It's a symmetrical pose; both legs assume the same position.

Knees are prominent

The lower legs angle inward.

Front View

You shouldn't be able to see the far foot.

Deep, graceful bend to the back.

Side View

The lower leg is hidden behind the thigh.

Lower leg overlaps the thigh

¾ View

RECLINING POSE

Reclining poses cause different sections of the body to shift directions. For example, the head pokes up, the torso lifts off the ground, and the legs remain horizontal.

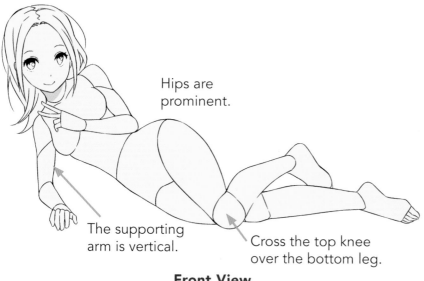

Hips are prominent.

The supporting arm is vertical.

Cross the top knee over the bottom leg.

Front View

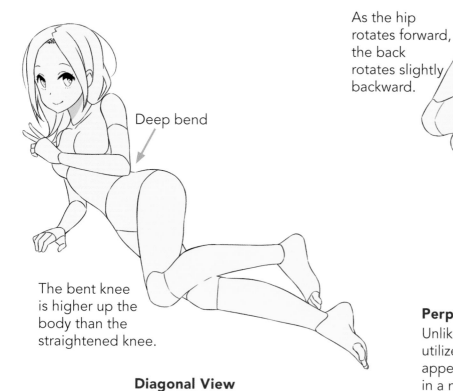

Deep bend

The bent knee is higher up the body than the straightened knee.

Diagonal View

As the hip rotates forward, the back rotates slightly backward.

The supporting arm is barely visible.

Perpendicular View

Unlike the other two poses, this one utilizes *perspective*. The feet, therefore, appear slightly bigger than they would in a non-perspective pose.

Expressive Sitting and Reclining Poses

Now let's add some context to the poses. We begin by creating a body *expression*. Draw what you feel. A pose is more interesting if it's imbued with some feeling or attitude.

SAD GIRL (KNEES UP POSE)

Here we see how effective a pose can be in creating a bond between the character and the viewer. Pulling the knees up to the chest is a lonesome look. We start to care about the character. We almost want to comfort her.

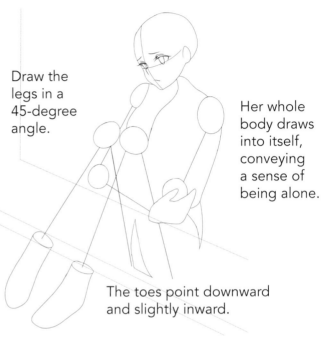

Draw the legs in a 45-degree angle.

Her whole body draws into itself, conveying a sense of being alone.

The toes point downward and slightly inward.

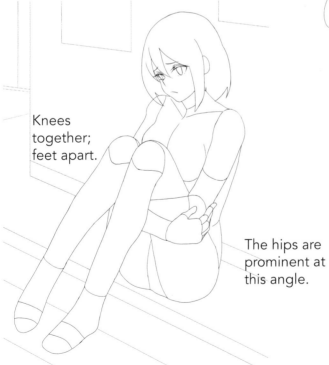

Knees together; feet apart.

The hips are prominent at this angle.

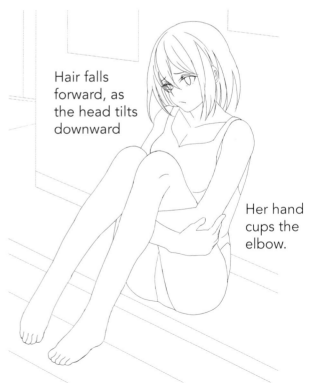

Hair falls forward, as the head tilts downward

Her hand cups the elbow.

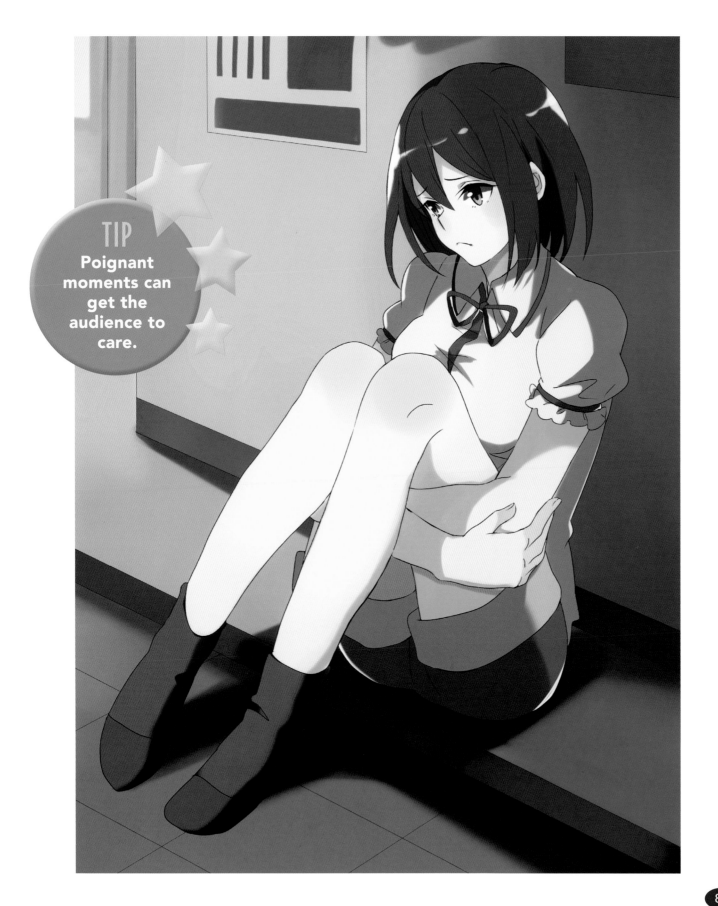

TIP
Poignant moments can get the audience to care.

SITTING AT A DESK (HIGH ANGLE)

Because many anime shows take place in a high school setting, this pose is a must for aspiring anime artists. A high angle is created when the vantage point comes from above and looks down at the character. She appears to be in a good mood. Must be that the bell is about to ring.

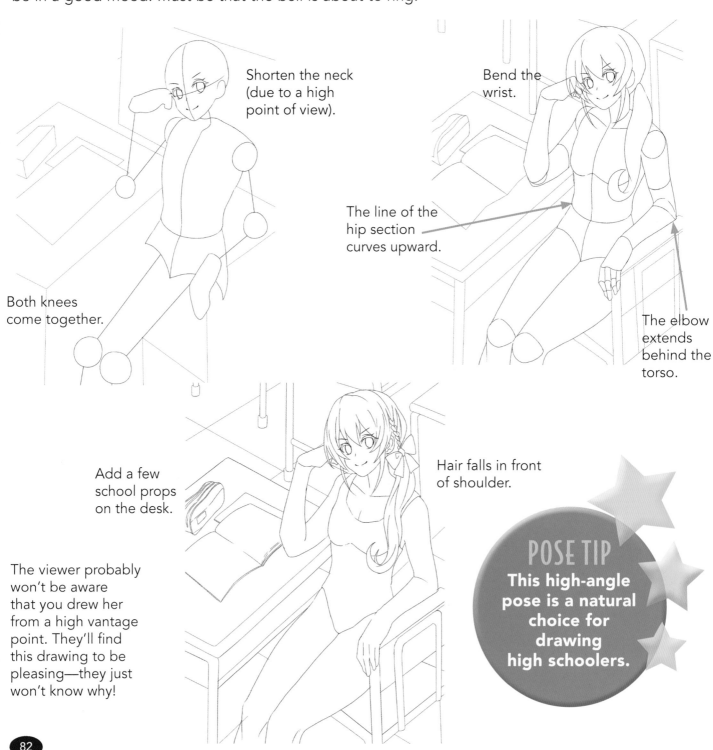

Shorten the neck (due to a high point of view).

Both knees come together.

Bend the wrist.

The line of the hip section curves upward.

The elbow extends behind the torso.

Add a few school props on the desk.

Hair falls in front of shoulder.

The viewer probably won't be aware that you drew her from a high vantage point. They'll find this drawing to be pleasing—they just won't know why!

POSE TIP
This high-angle pose is a natural choice for drawing high schoolers.

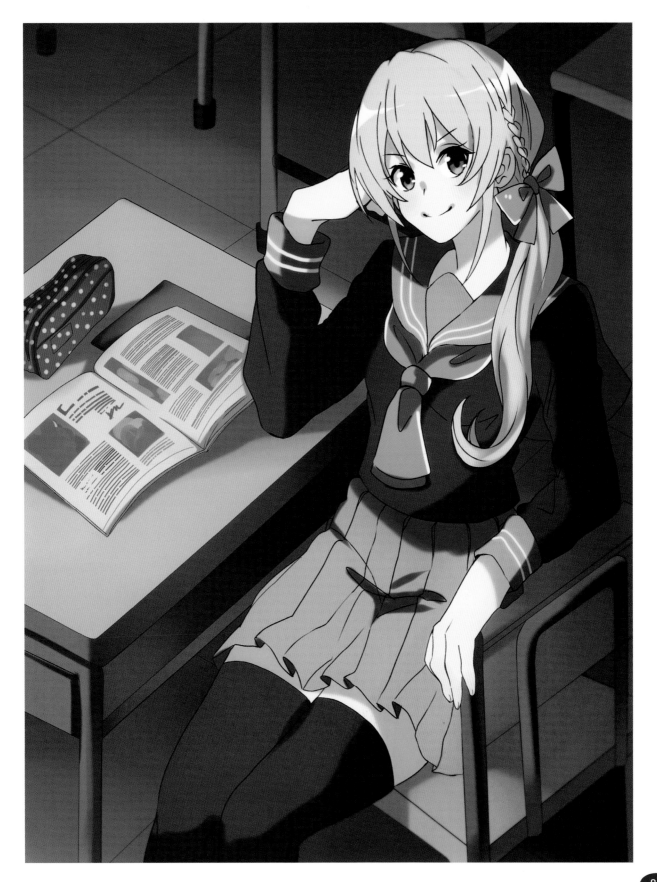

A QUIET MOMENT (RECLINING, STOMACH-SIDE DOWN)

Everyone needs some time alone away from modern life. Is there such a place? Yes: the park. Every city has one with flowers and a beautiful landscape. There's no nicer place to enjoy nature. I wonder if it has Wi-Fi.

At this angle, the head overlaps the neck.

The body is drawn in sections that overlap.

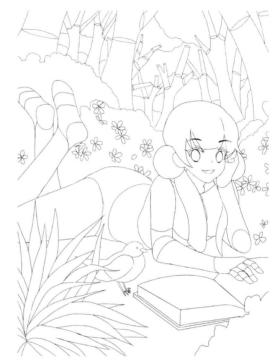

The hairbuns are drawn low.

BACKGROUND TIP

When a character lies on her stomach, the contours mainly appear on her back.

Cross the ankles for a playful look.

Turning the legs up indicates a cheerful pose. People don't pose that way unless they're in a good mood.

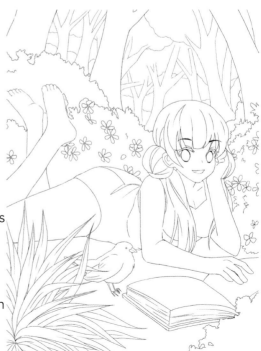

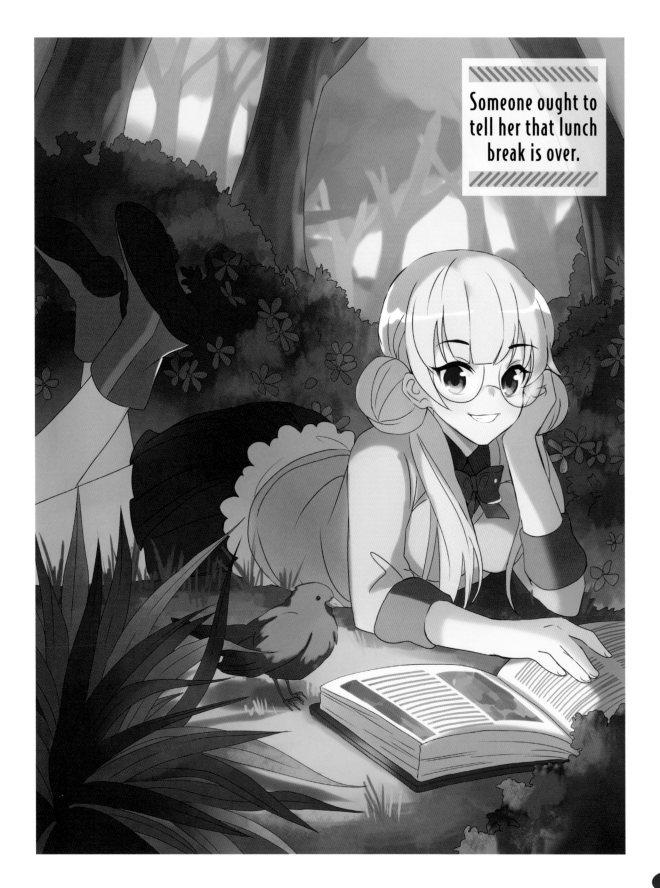

Someone ought to tell her that lunch break is over.

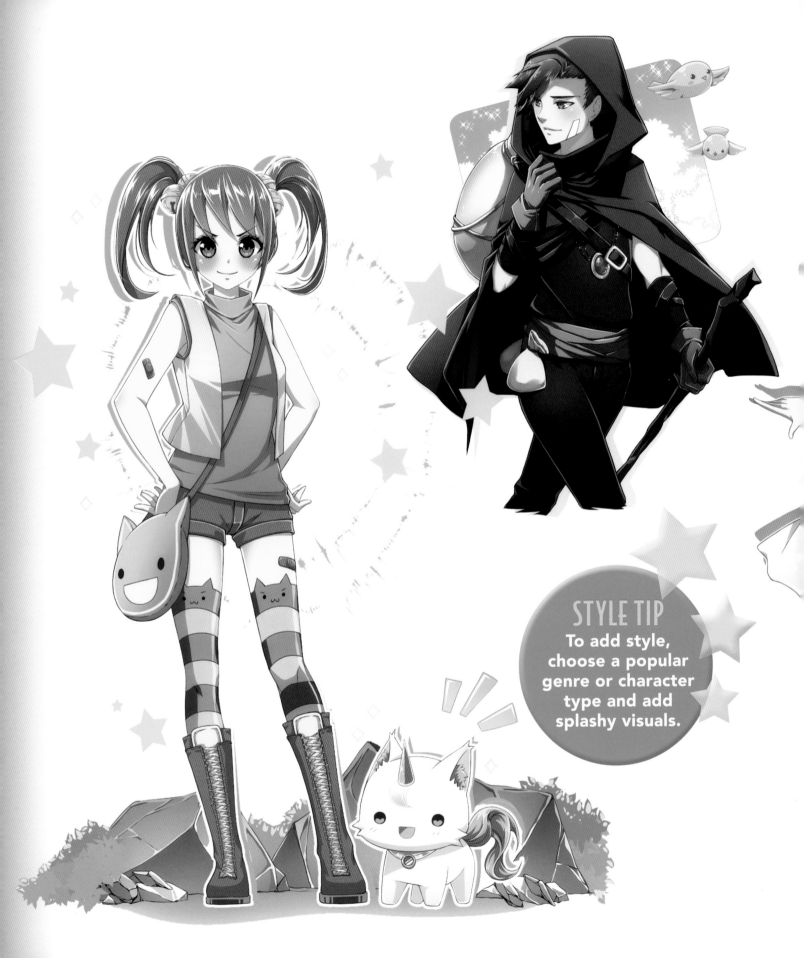

STYLE TIP
To add style, choose a popular genre or character type and add splashy visuals.

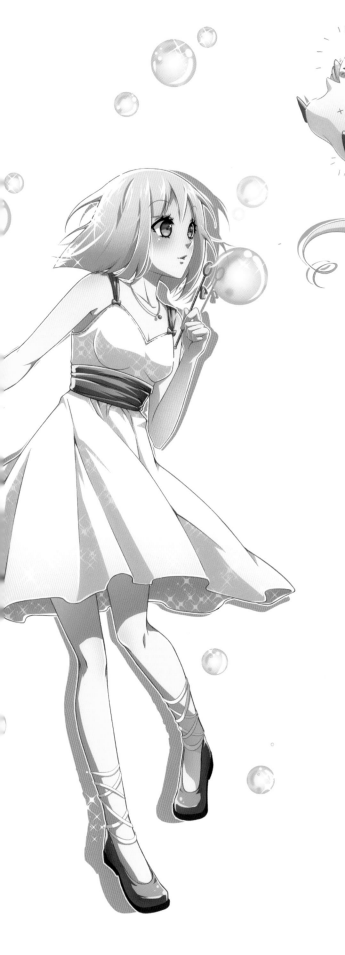

Developing a Sense of Style

Developing a drawing style doesn't mean that your drawings have to look radically different from everyone else's. It simply means emphasizing a theme or concept in an eyecatching way. For example, if you want to draw a magical girl, you might emphasize princess-style hair and a mystical dress. All the characters in this chapter are based on a popular anime theme. Let's see how we draw them with style.

Character Design Tip

Each of the characters in this chapter has something extra that makes them stand out. Remember this tip: It's better to exaggerate one main aspect of a character than to tweak a lot of minor ones.

TIP
Combine the conventional with the unconventional.

SCHOOLGIRL KEMONOMIMI (FOX EARS)

Kemenomimi is a Japanese term for any human anime character with animal ears. The most popular animal ears are feline, but they can also be fox, bear, bunny—mostly anything cute. Kemenomimi can be seen in all genres. This character contrasts unique fox features with a conventional schoolgirl outfit for a look that stands out.

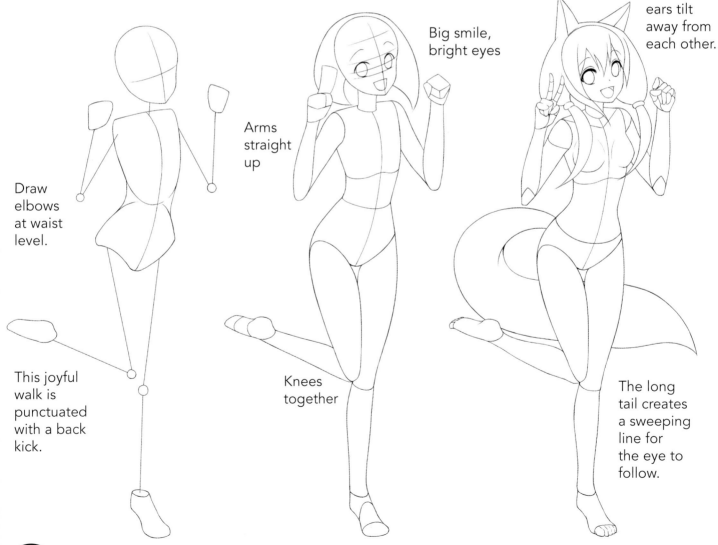

Draw elbows at waist level.

This joyful walk is punctuated with a back kick.

Arms straight up

Big smile, bright eyes

Knees together

Pointed ears tilt away from each other.

The long tail creates a sweeping line for the eye to follow.

Draw a line to suggest interior of ears.

The tips of the ears and the tips of the tail are darkened—just as they are on a real fox.

This unconventional character is dressed in a conventional school outfit, creating an interesting contrast for audiences.

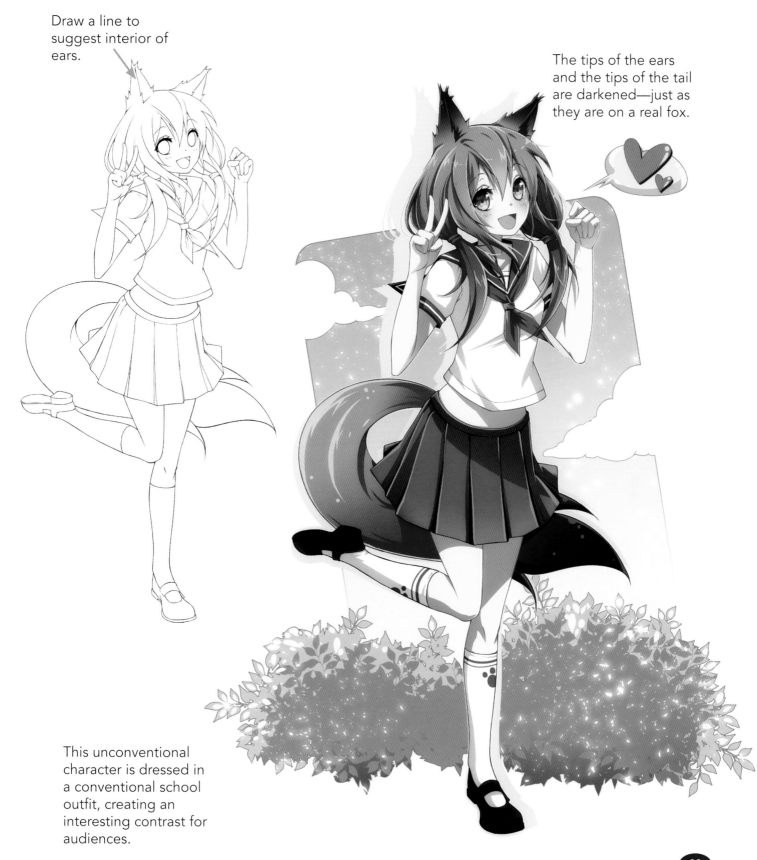

POP TYPES

The pop-culture girl is a major character type. She could be a singer, dancer, or performer, but she's usually a pop star. To make a pop type, draw a lively, super-colorful outfit with stripes and adorable icons.

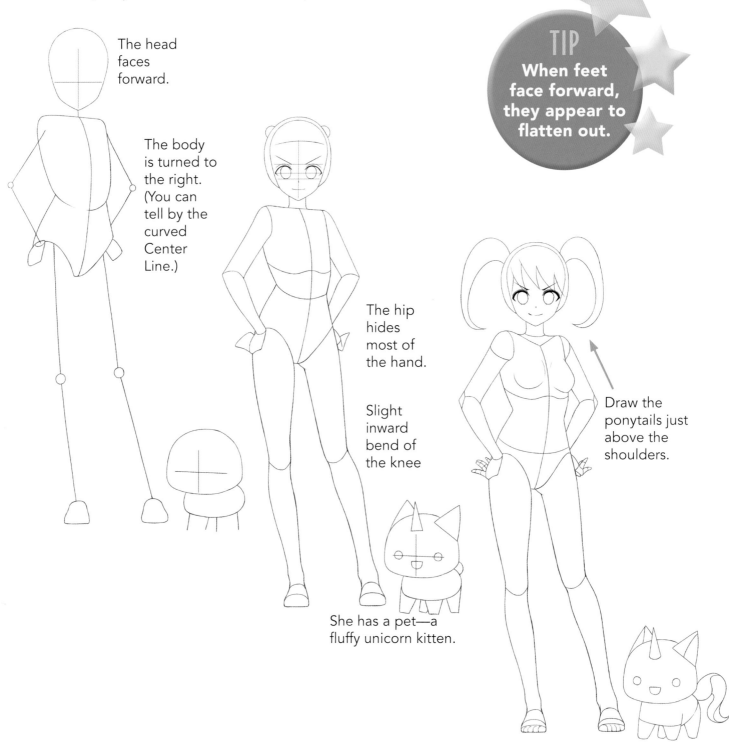

The head faces forward.

The body is turned to the right. (You can tell by the curved Center Line.)

TIP
When feet face forward, they appear to flatten out.

The hip hides most of the hand.

Slight inward bend of the knee

She has a pet—a fluffy unicorn kitten.

Draw the ponytails just above the shoulders.

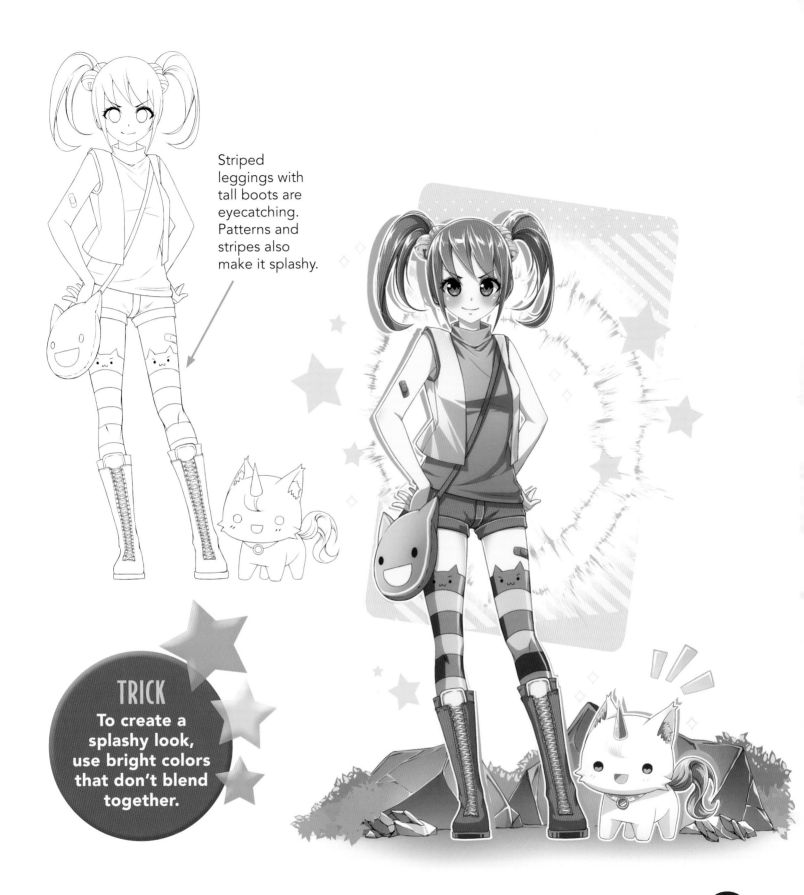

Striped leggings with tall boots are eyecatching. Patterns and stripes also make it splashy.

TRICK
To create a splashy look, use bright colors that don't blend together.

GIRL FROM ANOTHER DIMENSION

Characters from another dimension are mysterious. Where do they come from? Who are they? To emphasize the mysterious outfit, let's focus on the outfit and colors.

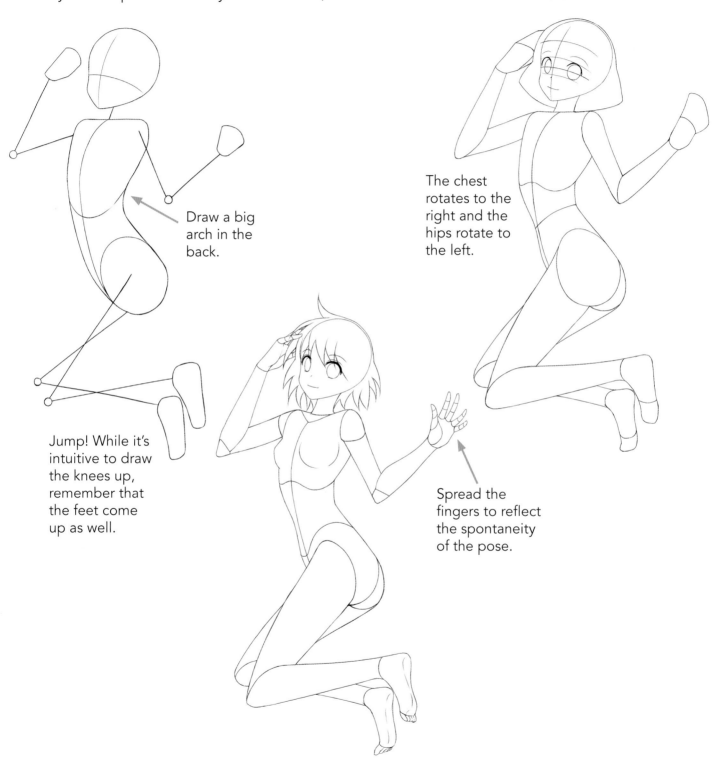

Draw a big arch in the back.

The chest rotates to the right and the hips rotate to the left.

Jump! While it's intuitive to draw the knees up, remember that the feet come up as well.

Spread the fingers to reflect the spontaneity of the pose.

Draw a hood and cape. The cape appears to almost float in the air.

This character from another dimension is visiting our little blue planet for the first time. What does she want to see most? A New York pizzeria. You just can't get good Italian food on Alpha Centauri.

Luminous eyes contrast against the dark color scheme.

Scarf conceals part of face.

Show the underside of the boots.

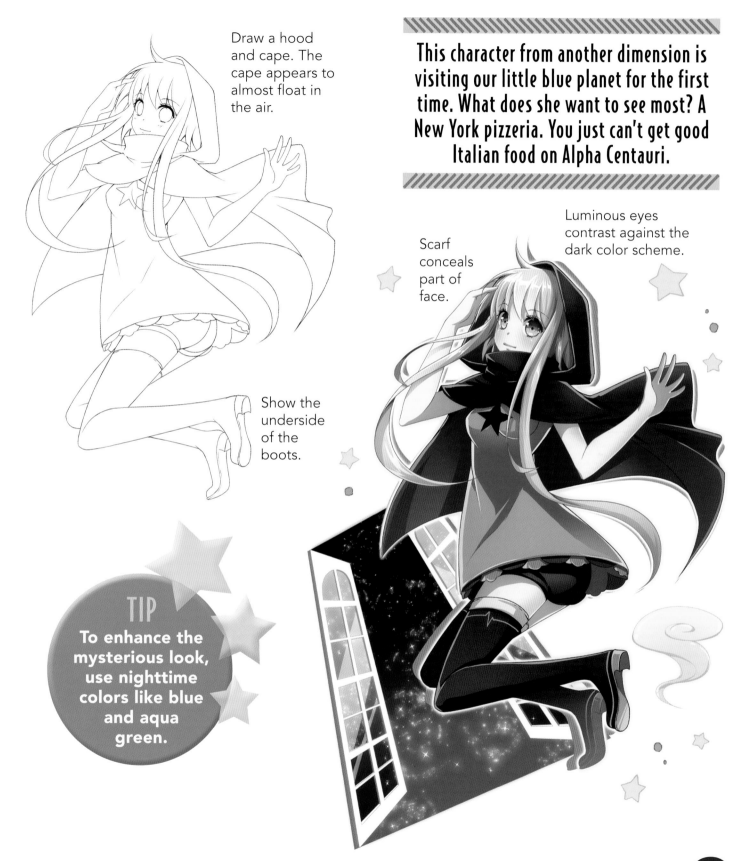

TIP

To enhance the mysterious look, use nighttime colors like blue and aqua green.

MASTER SWORDFIGHTER

This type is incredibly popular in anime. It's obvious that the armor stands out. But how do we give it style? Simple: Make it fashionable, as if it were part of an outfit.

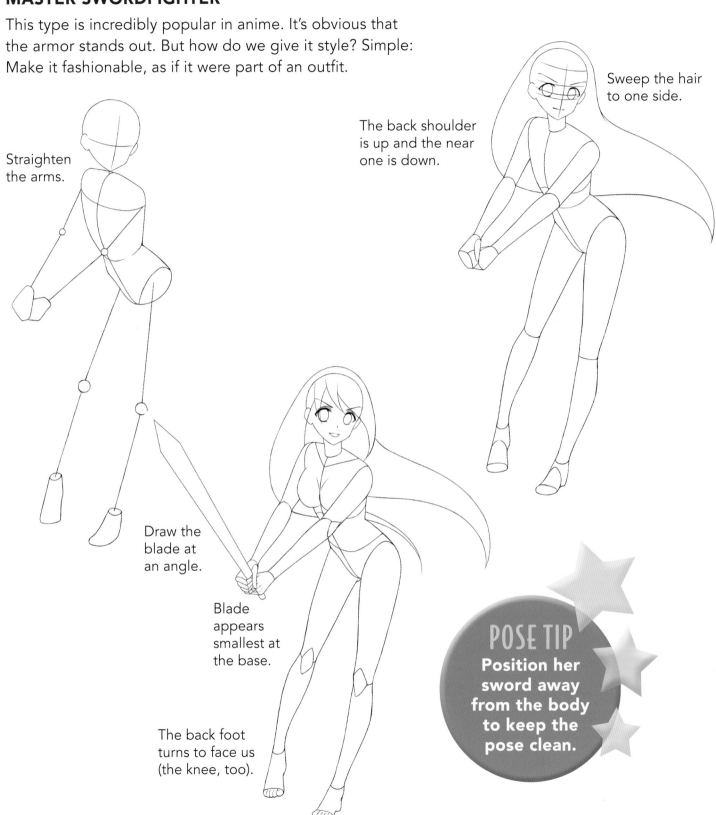

Straighten the arms.

The back shoulder is up and the near one is down.

Sweep the hair to one side.

Draw the blade at an angle.

Blade appears smallest at the base.

The back foot turns to face us (the knee, too).

POSE TIP
Position her sword away from the body to keep the pose clean.

94

Extended shoulder guards is a cool look.

How does a parent work up the courage to tell her to clean her room?

Tapered armor vest

Stylish skirt

Tall boots mimic leggings

The outfit features a classic fantasy color combination: purple and red.

STYLE TIP
Give her a pointed tiara— warrior style— as the finishing touch.

Crystals are typically colored with various shades of blue and white.

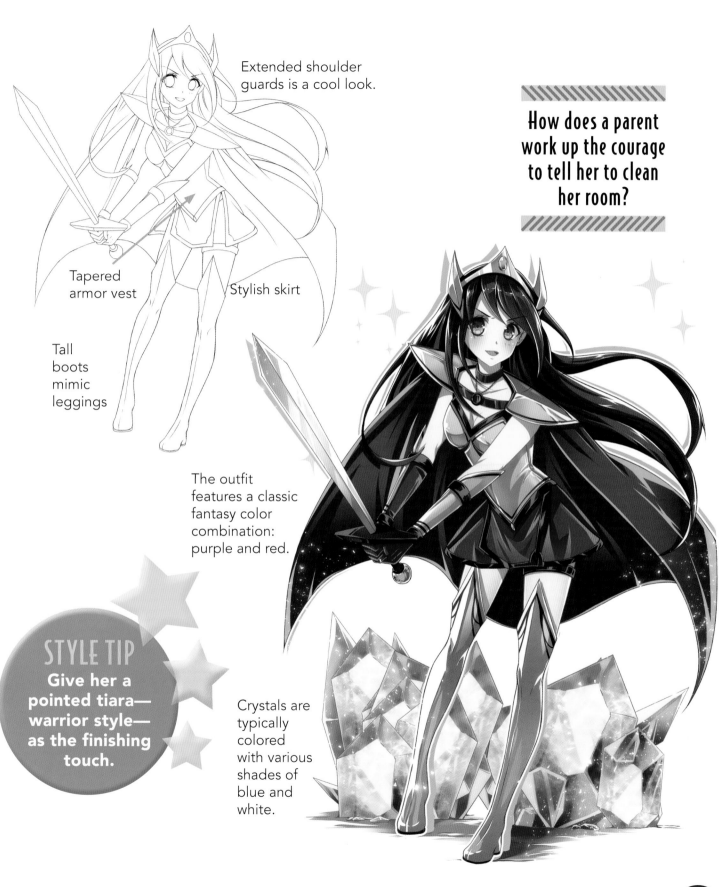

STYLISH SCHOOLBOY

The most formal outfit I wore to high school was a t-shirt with the logo of my favorite sports team. But anime characters go all out with tailored, stylish suits and jackets.

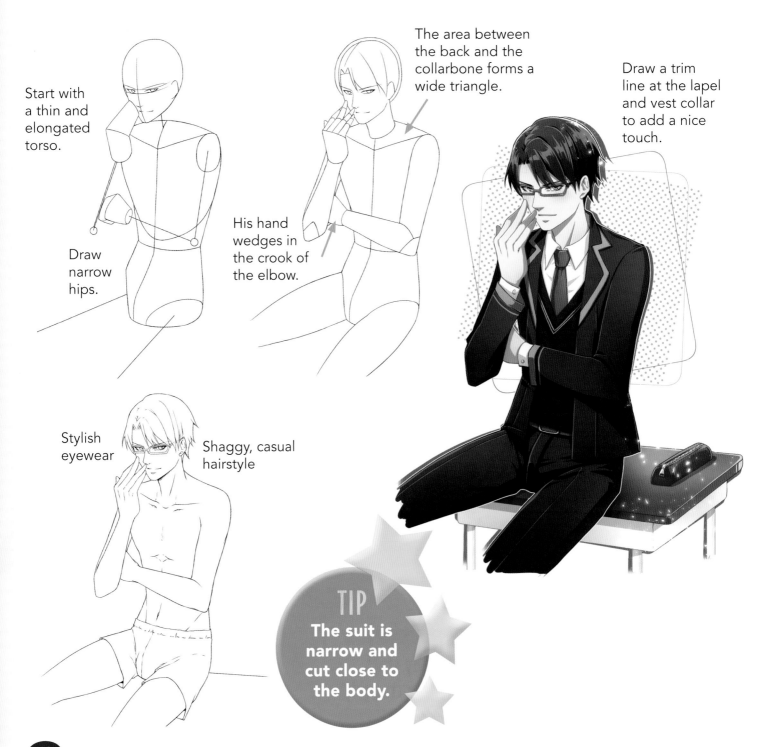

Start with a thin and elongated torso.

Draw narrow hips.

The area between the back and the collarbone forms a wide triangle.

His hand wedges in the crook of the elbow.

Draw a trim line at the lapel and vest collar to add a nice touch.

Stylish eyewear

Shaggy, casual hairstyle

TIP
The suit is narrow and cut close to the body.

COMEDY TYPE: BOY

Practical jokers can get big laughs. Unfortunately, they can also get everyone mad at them. Give this character a big expression and pose. Add a humorous outfit that lacks even a hint of fashion sense.

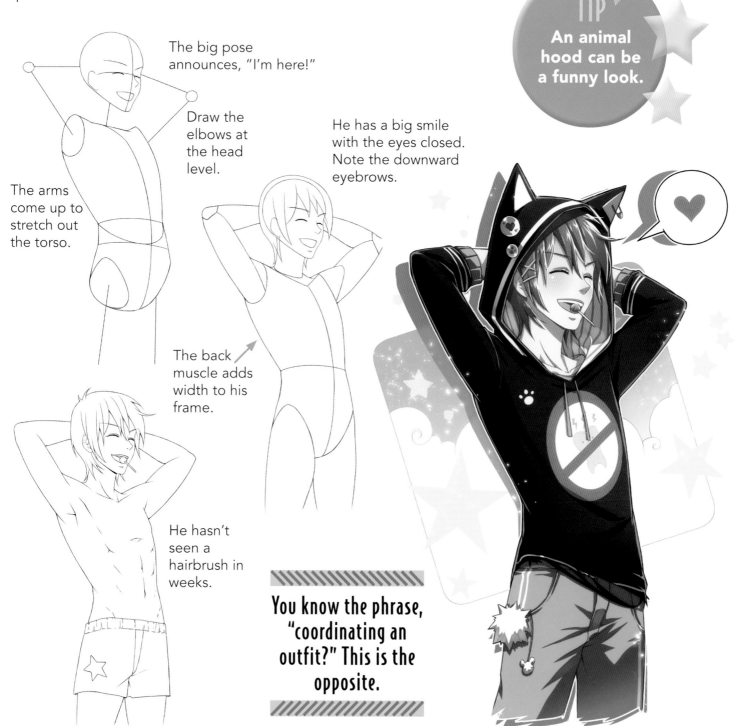

The big pose announces, "I'm here!"

Draw the elbows at the head level.

He has a big smile with the eyes closed. Note the downward eyebrows.

The arms come up to stretch out the torso.

The back muscle adds width to his frame.

He hasn't seen a hairbrush in weeks.

You know the phrase, "coordinating an outfit?" This is the opposite.

TIP
An animal hood can be a funny look.

COMIC TYPE: GIRL

The key to creating comedic characters is to combine their action, such as *shopping*, with a personality trait, such as *compulsivity*. What you get is a compulsive shopper who forgot her credit cards!

The head is centered directly over the body.

Jumping eyebrows and an O-shaped mouth is the classic, embarrassed expression.

The torso wedges into the hip section.

Draw two hair buns at a 45-degree angle to the head.

The hands are palms down with the thumbs facing in.

TIP For comic effect, use candy colors that clash like a train wreck.

But she needs all this stuff!

100

BUSY TEEN

This character type is often shown in a flurry of activity. She's turned multitasking into an Olympic sport.

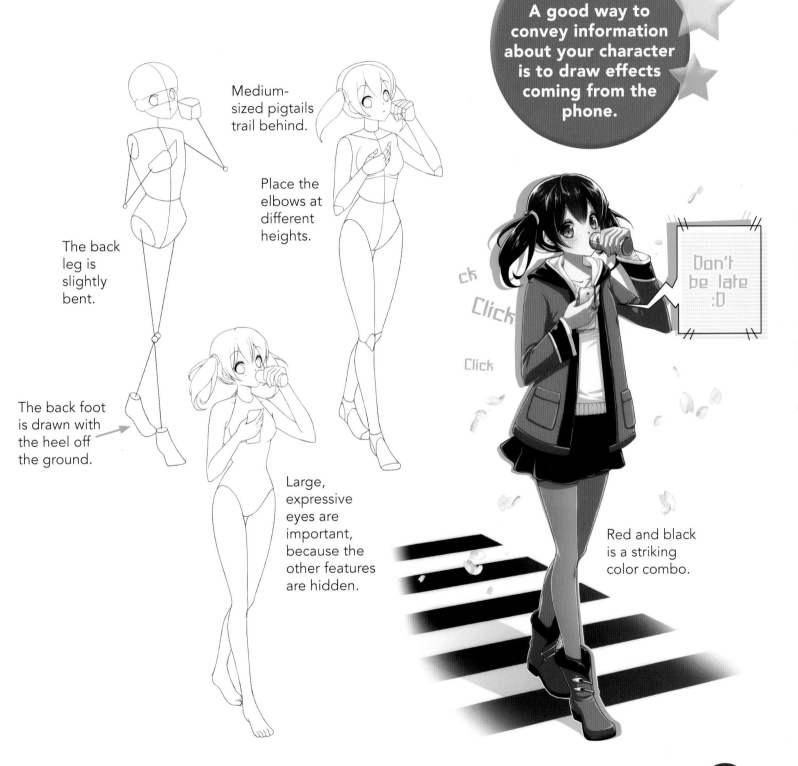

TRICK
A good way to convey information about your character is to draw effects coming from the phone.

Medium-sized pigtails trail behind.

Place the elbows at different heights.

The back leg is slightly bent.

The back foot is drawn with the heel off the ground.

Large, expressive eyes are important, because the other features are hidden.

Don't be late :D

ck Click

Click

Red and black is a striking color combo.

WHIMSICAL

How would you describe whimsical? Some would say it's lying in a field of flowers. But we can all agree that an anime girl blowing bubbles at a ticklish, flying creature is definitely whimsical. Now let's check out the specifics.

To set up the pose, draw her leaning forward.

A swirling tail is a whimsical addition.

Extend arm.

White shines inside of light blue bubbles create a reflective appearance.

PLOP

PLOP

He may need to go on a diet, but I hope he doesn't.

Her bent leg, faces inward playfully.

Vary the size of the bubbles.

The twists in the skirt suggest action.

TEAM CAPTAIN

On the field, she knows exactly what she's doing. But in a social setting, she's clueless, which creates a funny character type.

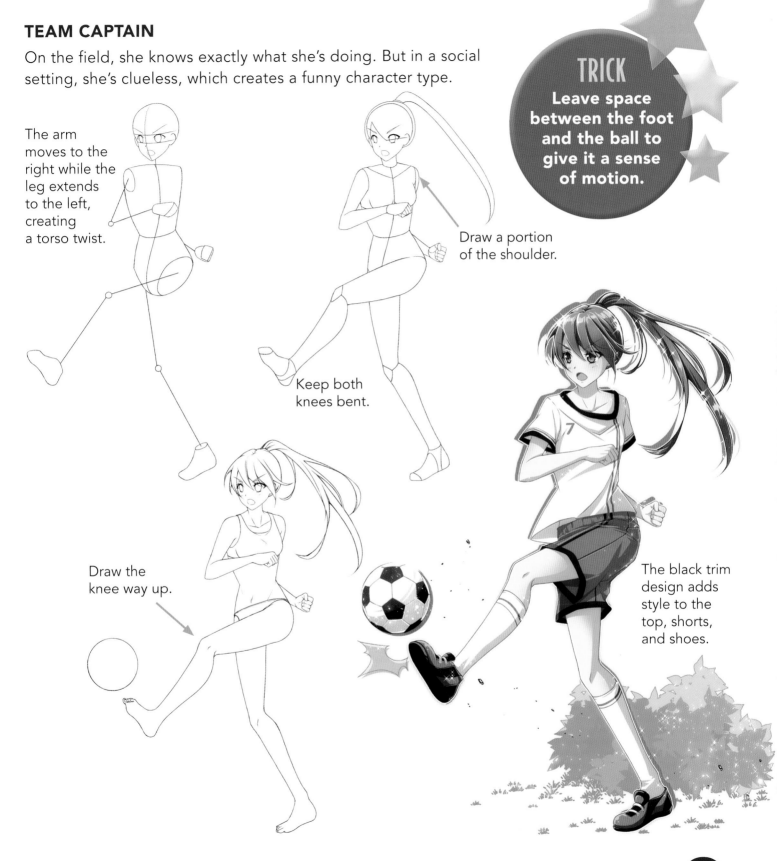

The arm moves to the right while the leg extends to the left, creating a torso twist.

Draw a portion of the shoulder.

TRICK

Leave space between the foot and the ball to give it a sense of motion.

Keep both knees bent.

Draw the knee way up.

The black trim design adds style to the top, shorts, and shoes.

FITNESS FANATIC

While her friends build sand castles under their sun umbrellas, she clocks miles. This character is often depicted with a cheerful intensity that she brings to everything.

TIP

In a running pose, the elbows rise and lower, but both knees remain at the same level.

Her upright posture connotes a jog rather than an all-out sprint.

Deep bend in the side

Draw the front leg straight.

The hair flies out behind her in wisps and tendrils to indicate movement.

The back leg is darkened, to suggest that it's receding to the back.

SLAPSTICK

There's always one character that fits the saying: "Anything that can go wrong will." He usually looks confused and overwhelmed. He's the only character that can lose a tug-of-war with an eight-pound puppy.

TRICK
Slapstick adds a physical element to a humorous situation.

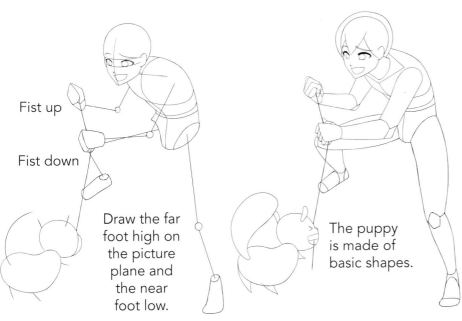

Fist up

Fist down

Draw the far foot high on the picture plane and the near foot low.

The puppy is made of basic shapes.

Messed-up hair and flustered expression

His head overlaps the far shoulder, hiding it from view.

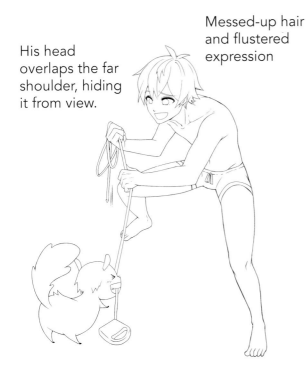

It's the puppy for the win!

HA HA HA

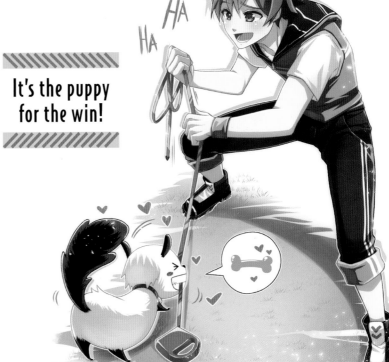

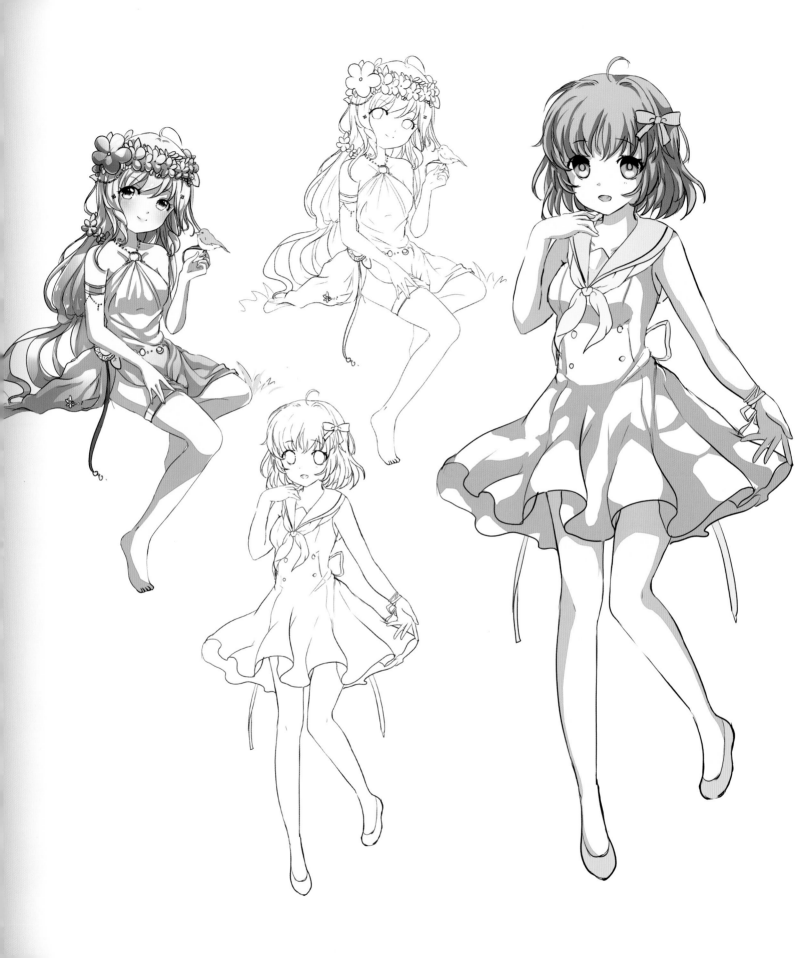

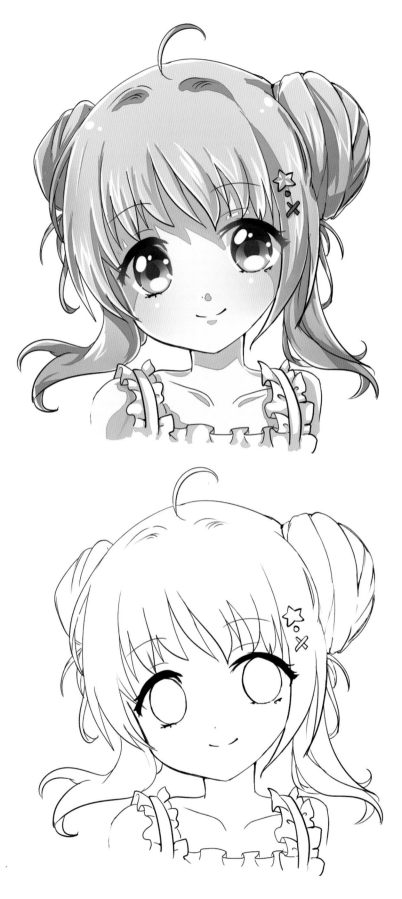

Shading and Color

If you're looking for a way to make your characters and settings eye-catching, then learning to apply shading and colors is the way to go. The approach to shading and coloring demonstrated in this chapter works for all media, including pencils, markers, and digital coloring tools. Before we begin, bear in mind that a little shading goes a long way. Therefore, use restraint when you add color and shading. This, however, creates another paradox: if you use restraint all the time, are you really using it?

TIP
A little shading goes a long way. But don't overdo it!

First Draw, then Color, then Shade

Everything goes in order, except for people waiting in line at the DMV. So before we add color, let's complete the line drawing. You'll notice that the eyes and hair in step three look flat. This is where people usually stop, but we're going to use this as the starting point for shading, coloring, and applying highlights.

Even the most beautiful character starts with a simple construction.

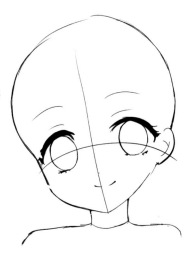

Here, we've jumped ahead to the finished line drawing so that we can begin to demonstrate adding color and tone.

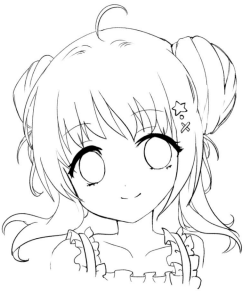

These are what are called *flat colors*. Without shading or tone, they lack impact.

Now start to apply some subtle shading under the bangs, chin, and on the shoulders.

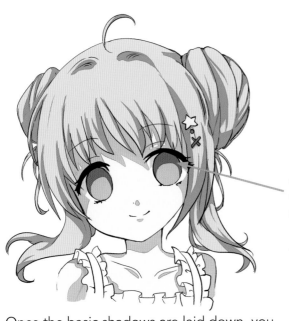

Add shadow on top of the eye—very important in anime!

Once the basic shadows are laid down, you can define the strands of hair. If you're drawing in black and white, you can do this with pencil shading. When you shade with color, use a darker color version of the hair color.

Create white highlights on the hair, just above the bangs, and on the eyes. (If you're working in pencil, simply erase the areas that you'd like to see shiny.

TIP
To add shading to a color, use a darker version of the same color.

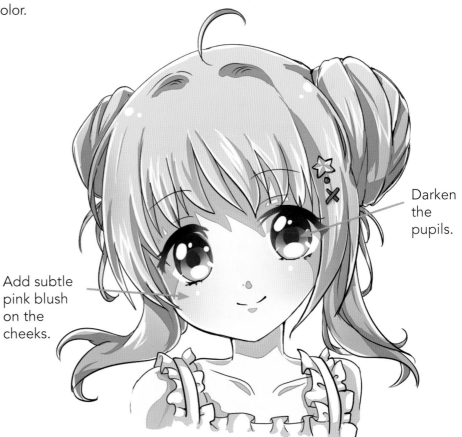

Darken the pupils.

Add subtle pink blush on the cheeks.

FINISHING TOUCHES

What Is Cel Shading?

Cel shading is a term that derives from animation. Animated cartoon characters used to be inked and painted onto celluloid sheets, which would create vibrant reflective color images. This creates a hard, shaded line. It's hugely popular in anime.

 With cel shading, there's no gradation. In other words, the shading does not get brighter or darker as it moves into or out of shadow. It's always a solid block of tone. It's also known as *hard shading*. Let's see how it works.

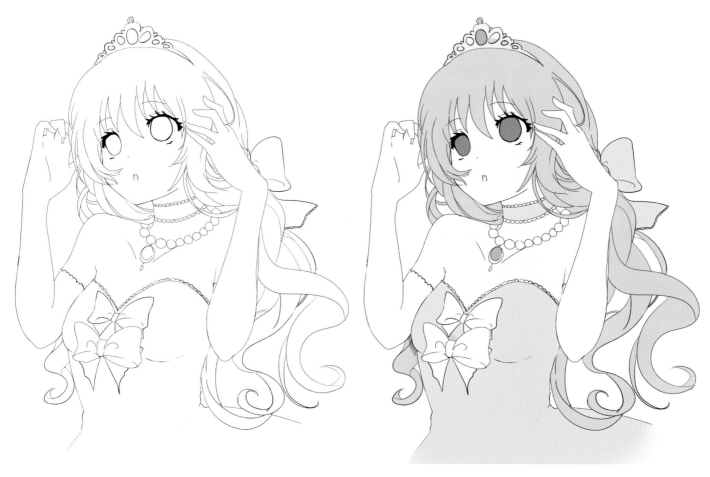

Basic line drawing

Flat colors
(Or the *flats*, as they're
sometimes called.)

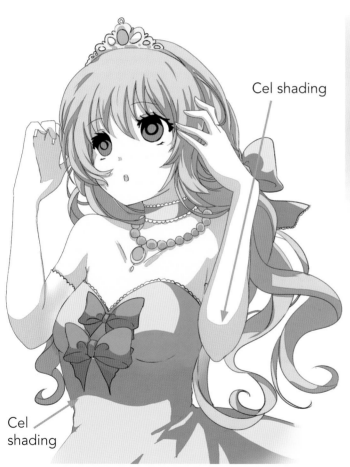

Cel shading

Cel shading

Cel shading

The shading is so definite that you can practically trace its outline with a pencil.

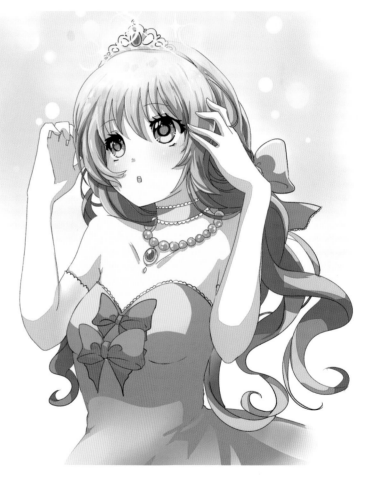

Soft shading

Cel shading is used on the character, but *soft shading* is also used to create the atmospheric glow around the character.

Work in Stages

Everyone has his or her own way of doing things. However, most professional anime artists work in stages, going from the general to the more detailed. This actually turns out to be the simpler approach. It beats starting with the details and then going back to redo the basics if the drawing doesn't come out right.

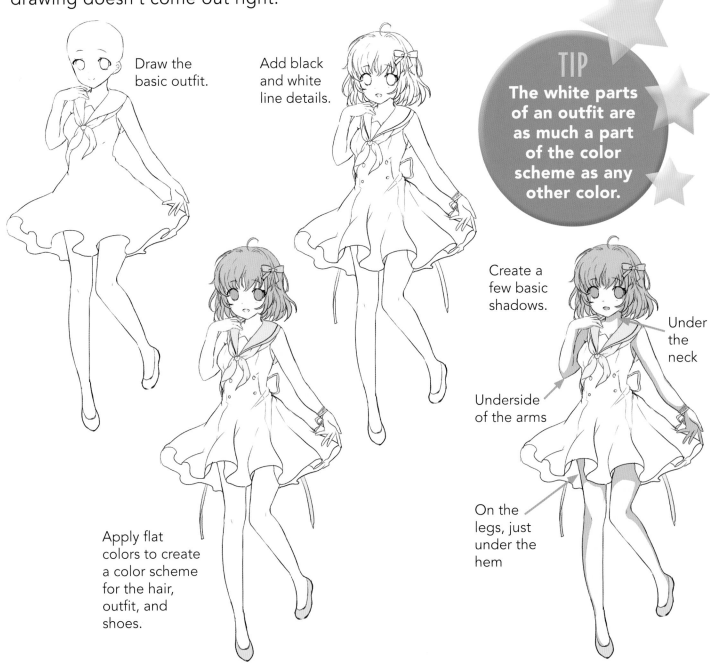

Draw the basic outfit.

Add black and white line details.

TIP
The white parts of an outfit are as much a part of the color scheme as any other color.

Apply flat colors to create a color scheme for the hair, outfit, and shoes.

Create a few basic shadows.

Under the neck

Underside of the arms

On the legs, just under the hem

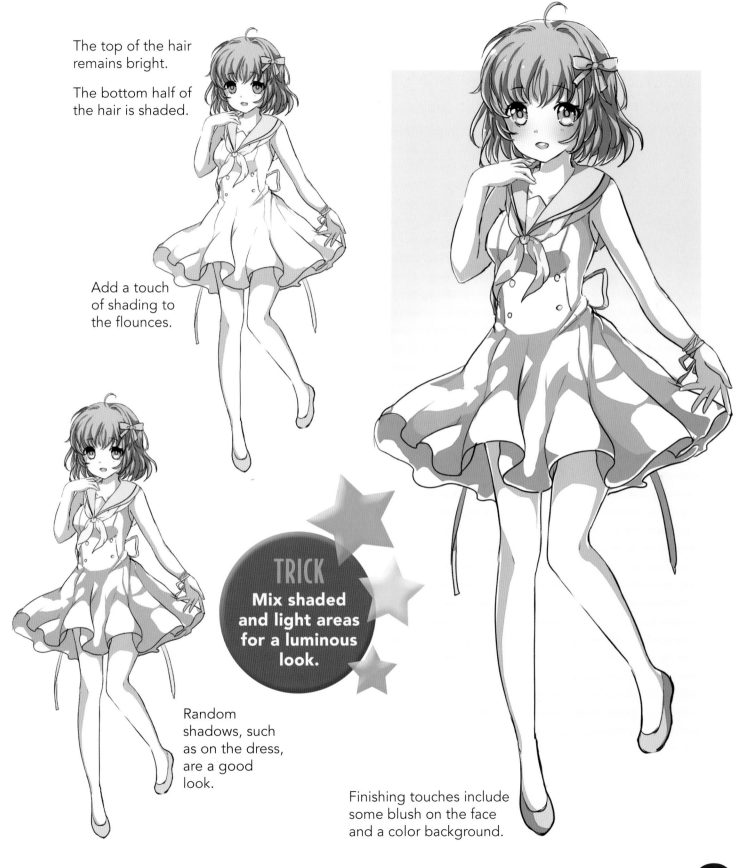

The top of the hair remains bright.

The bottom half of the hair is shaded.

Add a touch of shading to the flounces.

Random shadows, such as on the dress, are a good look.

TRICK

Mix shaded and light areas for a luminous look.

Finishing touches include some blush on the face and a color background.

Creating Atmospheric Images

Let's say you envision your character in a mystical, enchanted environment. In order for the image to be most effective, the character and the environment must work together. Some lighting effects should do the trick.

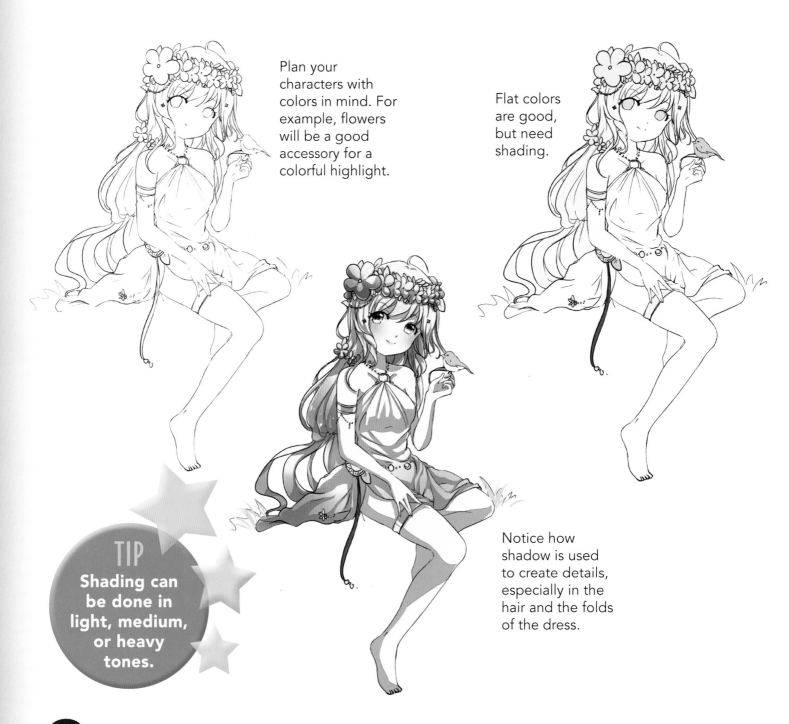

Plan your characters with colors in mind. For example, flowers will be a good accessory for a colorful highlight.

Flat colors are good, but need shading.

Notice how shadow is used to create details, especially in the hair and the folds of the dress.

TIP

Shading can be done in light, medium, or heavy tones.

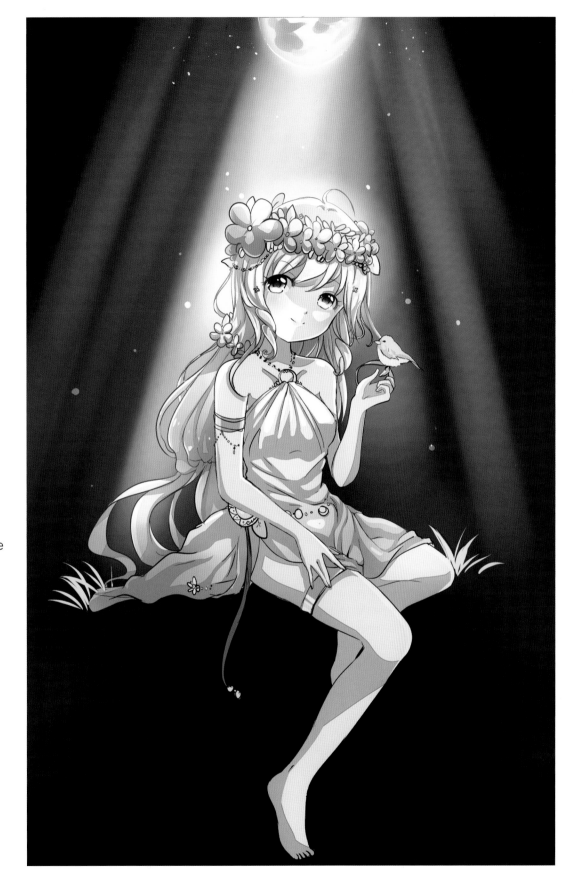

The shafts of light from overhead give the scene a magical aura and indicate the light source.

From Concept to Completion—Trapped Angel

Let's go for a big finish to this chapter. Are you ready? Let's create drama with colors, shading, and glowing effects. We'll want to start off with a compelling concept. It doesn't need to be complex. You're simply looking to evoke a response from the viewer. This concept is a simple one: An angel trapped by the forces of darkness.

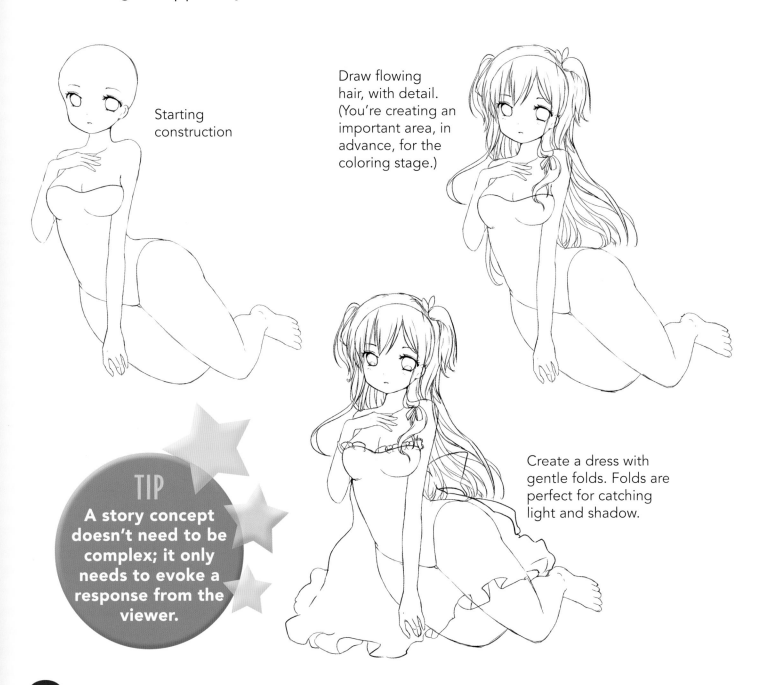

Starting construction

Draw flowing hair, with detail. (You're creating an important area, in advance, for the coloring stage.)

Create a dress with gentle folds. Folds are perfect for catching light and shadow.

TIP

A story concept doesn't need to be complex; it only needs to evoke a response from the viewer.

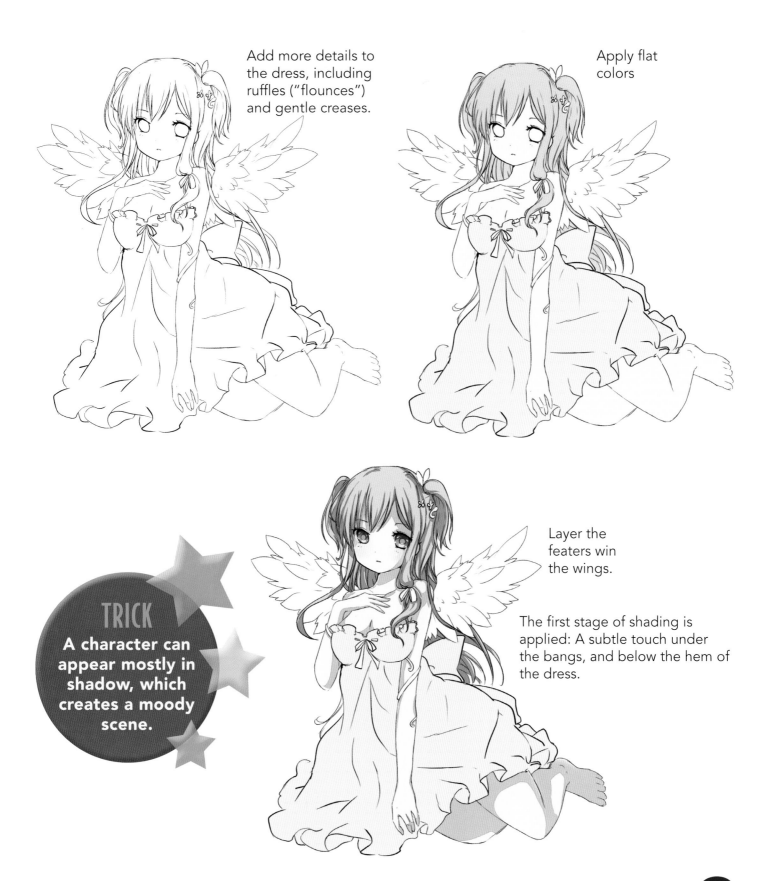

Add more details to the dress, including ruffles ("flounces") and gentle creases.

Apply flat colors

Layer the featers win the wings.

The first stage of shading is applied: A subtle touch under the bangs, and below the hem of the dress.

TRICK
A character can appear mostly in shadow, which creates a moody scene.

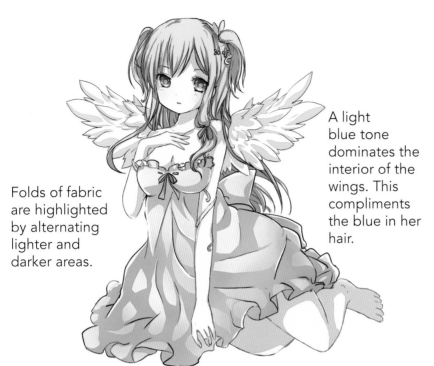

Folds of fabric are highlighted by alternating lighter and darker areas.

A light blue tone dominates the interior of the wings. This compliments the blue in her hair.

The box must be a degree lighter than the darkness behind it, or it won't appear to be transparent.

COLORING TRICK

A bright figure against a dark background creates a stunning look.

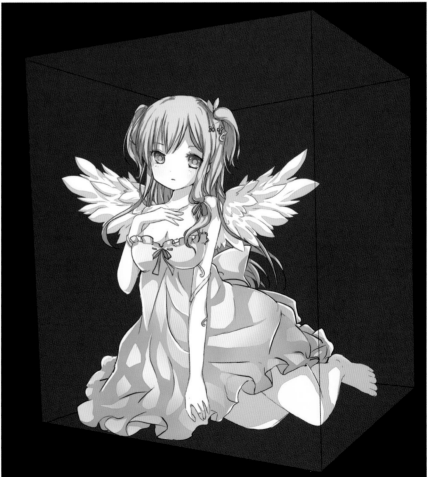

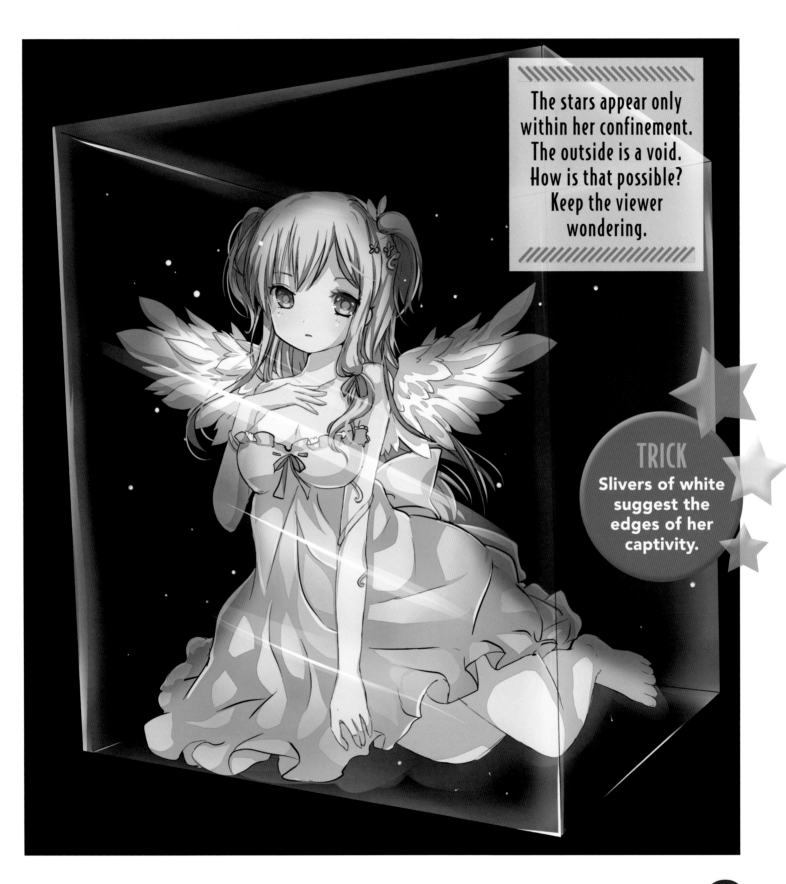

The stars appear only within her confinement. The outside is a void. How is that possible? Keep the viewer wondering.

TRICK
Slivers of white suggest the edges of her captivity.

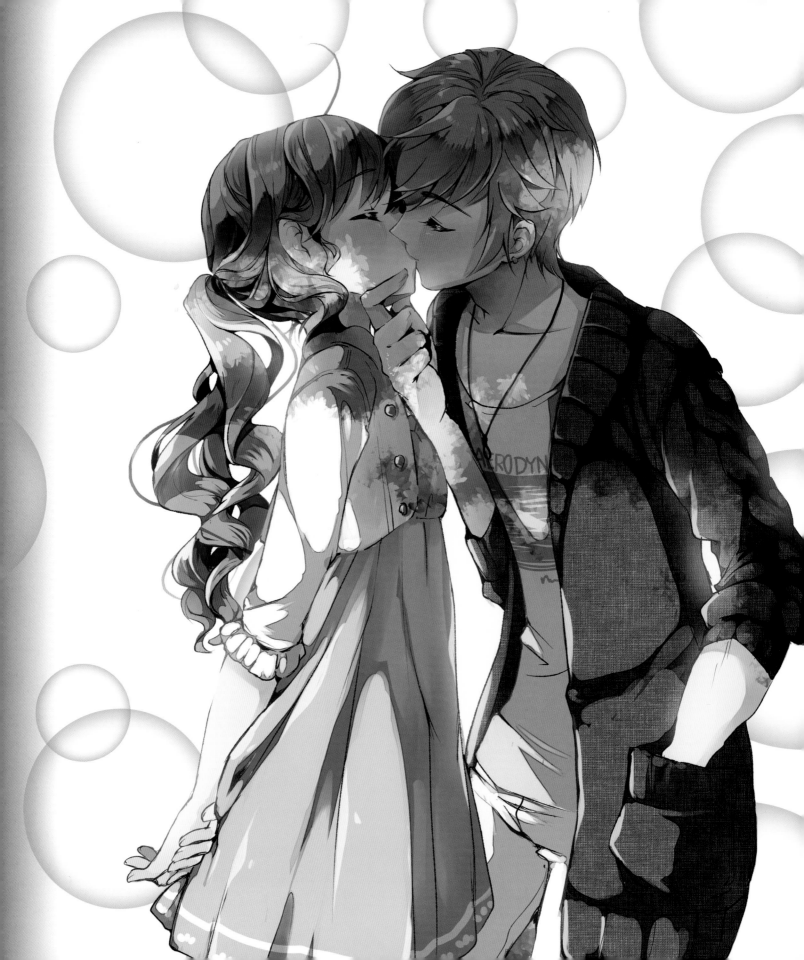

Drawing Couples

Everyone wants to draw couples, but many anime fans don't know how to begin.
There's a trick to drawing couples. Start with rough drawings without detail, and use them to establish the position of the two characters. Don't even start on the details before you settle on the composition. You could draw the best looking characters in the world, but if the layout is poor, there won't be any chemistry between them. And remember this: Simple compositions work the best. We'll put this advice to work in this chapter.

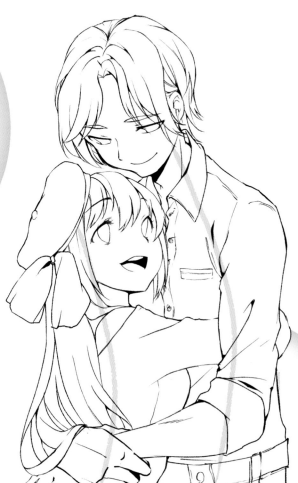

TRICK
When drawing couples, sketch both characters loosely until you have the placement the way you want it.

The Romantic Hug

This is the classic hug for two people in love. (You'll need a different pose when they break up!) This pose creates a dramatic dynamic, because one character is looking up as the other character is looking down. Now, let's go to the specifics.

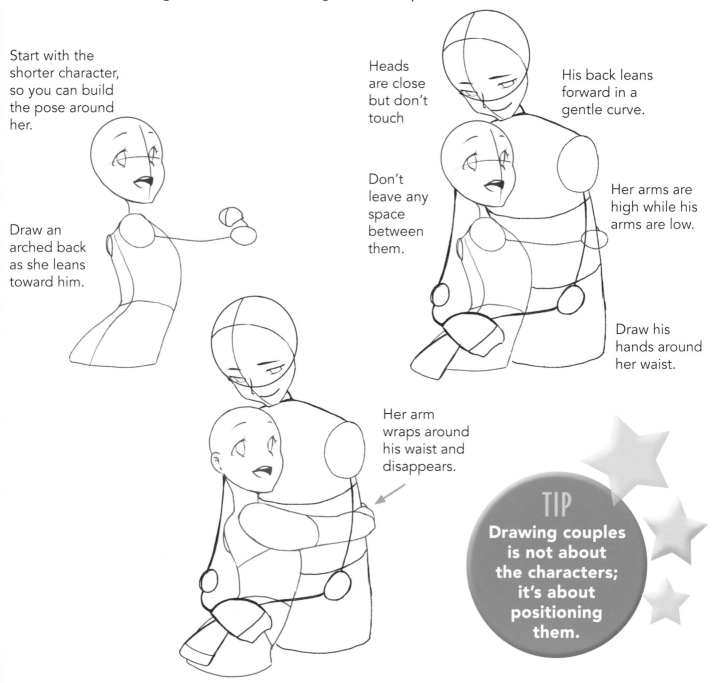

Start with the shorter character, so you can build the pose around her.

Draw an arched back as she leans toward him.

Heads are close but don't touch

Don't leave any space between them.

His back leans forward in a gentle curve.

Her arms are high while his arms are low.

Draw his hands around her waist.

Her arm wraps around his waist and disappears.

TIP
Drawing couples is not about the characters; it's about positioning them.

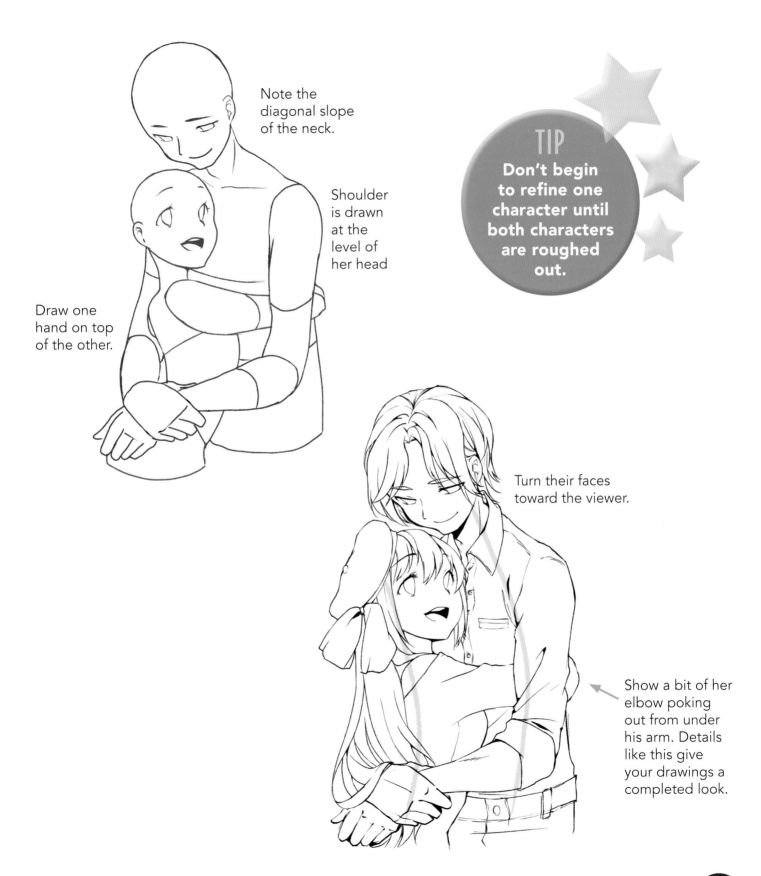

Note the diagonal slope of the neck.

Shoulder is drawn at the level of her head

Draw one hand on top of the other.

TIP
Don't begin to refine one character until both characters are roughed out.

Turn their faces toward the viewer.

Show a bit of her elbow poking out from under his arm. Details like this give your drawings a completed look.

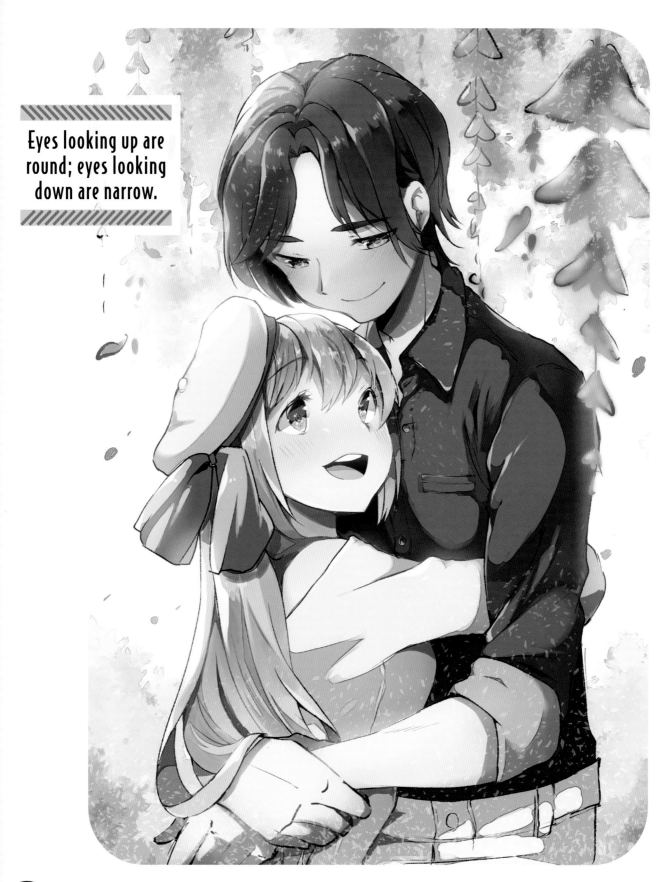

Eyes looking up are round; eyes looking down are narrow.

The Playful Hug

Romantic comedy is a staple in anime. It usually features an uneven infatuation. In many such stories, the girl is persistent. Very persistent. Therefore, in this pose, only one character is doing the hugging.

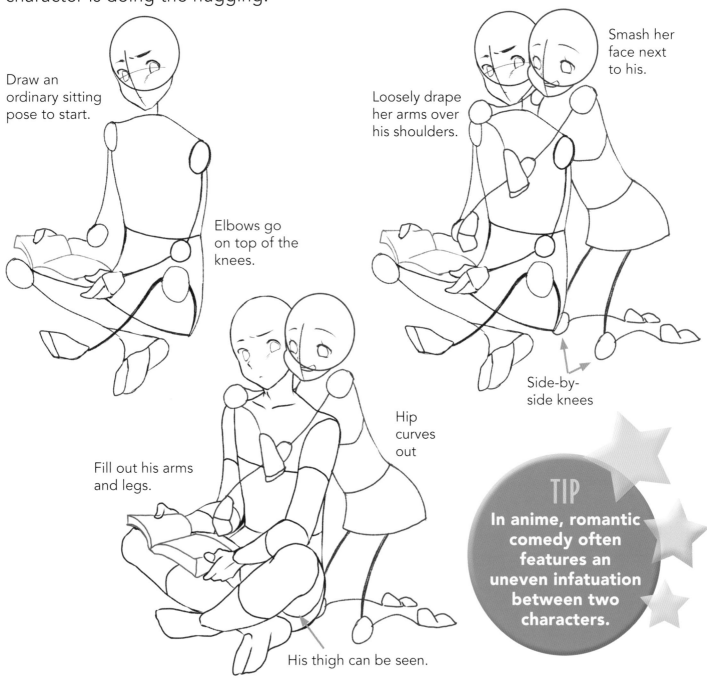

Draw an ordinary sitting pose to start.

Elbows go on top of the knees.

Loosely drape her arms over his shoulders.

Smash her face next to his.

Side-by-side knees

Fill out his arms and legs.

Hip curves out

His thigh can be seen.

TIP
In anime, romantic comedy often features an uneven infatuation between two characters.

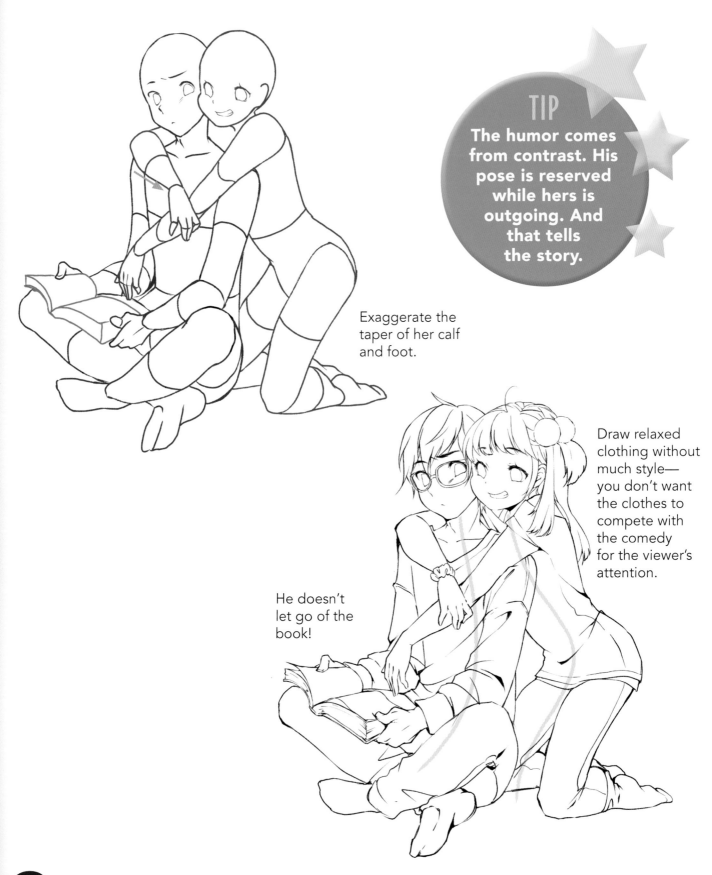

Exaggerate the taper of her calf and foot.

Draw relaxed clothing without much style— you don't want the clothes to compete with the comedy for the viewer's attention.

He doesn't let go of the book!

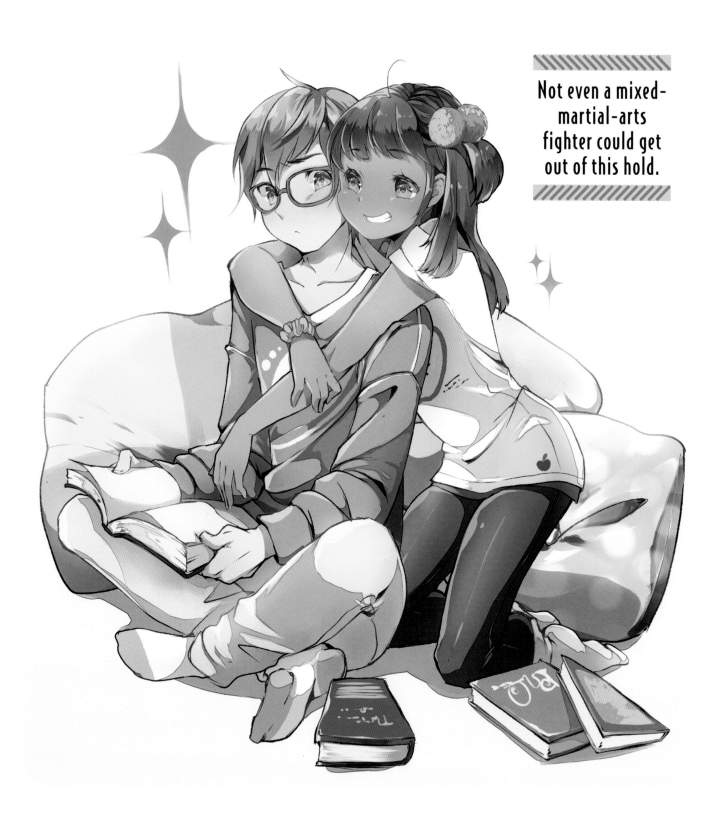

Not even a mixed-martial-arts fighter could get out of this hold.

The Protective Hug (Best Choice for Dramatic Stories)

The fantasy landscape is well suited to dramatic poses. Together, our intrepid couple will stare down fire-breathing dragons. Either character—man or woman—can be the protective one. To add more urgency to the scene, shards from a fireball rain down from the sky.

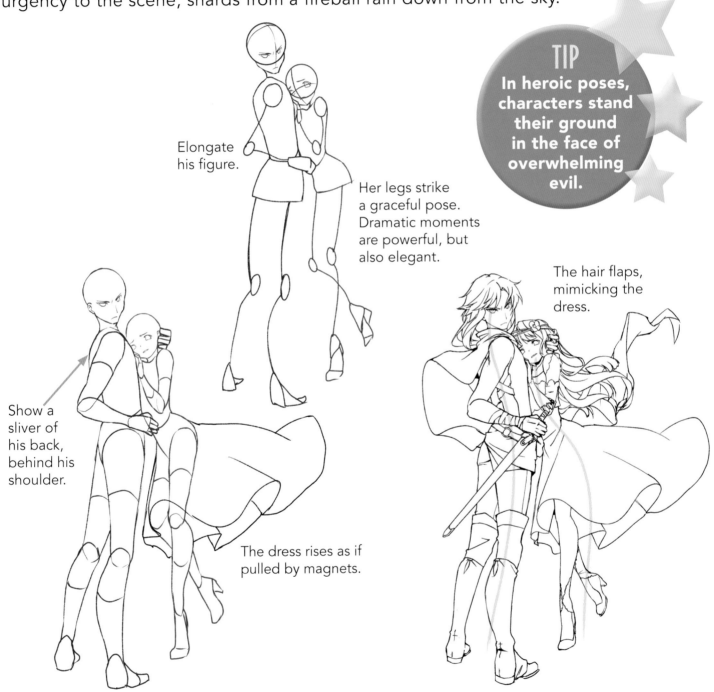

Elongate his figure.

Her legs strike a graceful pose. Dramatic moments are powerful, but also elegant.

TIP
In heroic poses, characters stand their ground in the face of overwhelming evil.

The hair flaps, mimicking the dress.

Show a sliver of his back, behind his shoulder.

The dress rises as if pulled by magnets.

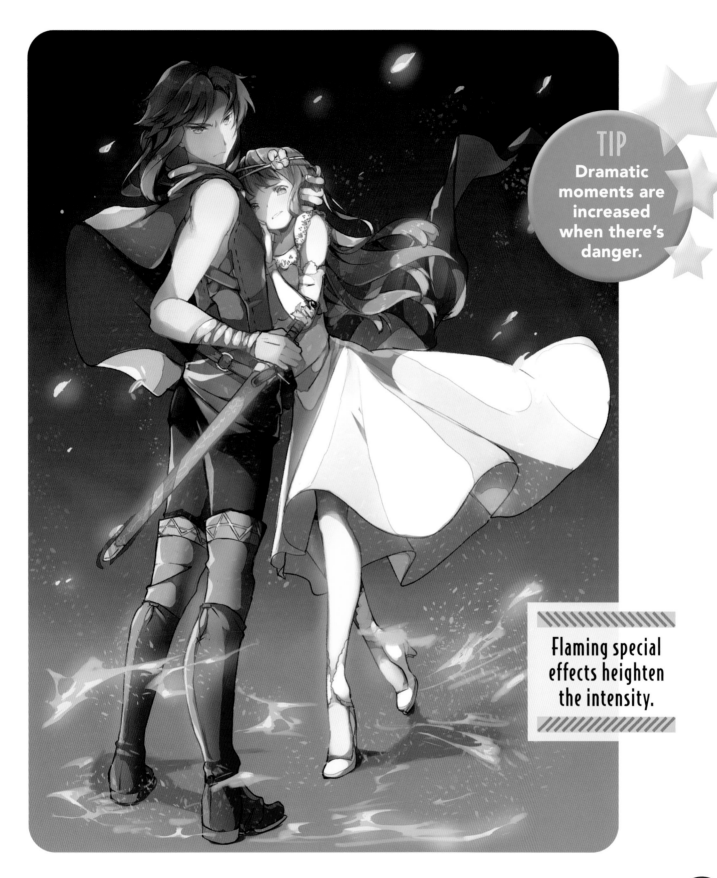

TIP
Dramatic moments are increased when there's danger.

Flaming special effects heighten the intensity.

The Kiss (Classic Pose)

Because the kiss is such an important moment in a story, many fans want to draw it. But how do you get the lips right? Here's the trick: This pose isn't about the lips. It's about positioning the heads so that they overlap. In fact, one character's lips don't even show. Let's check out the specifics.

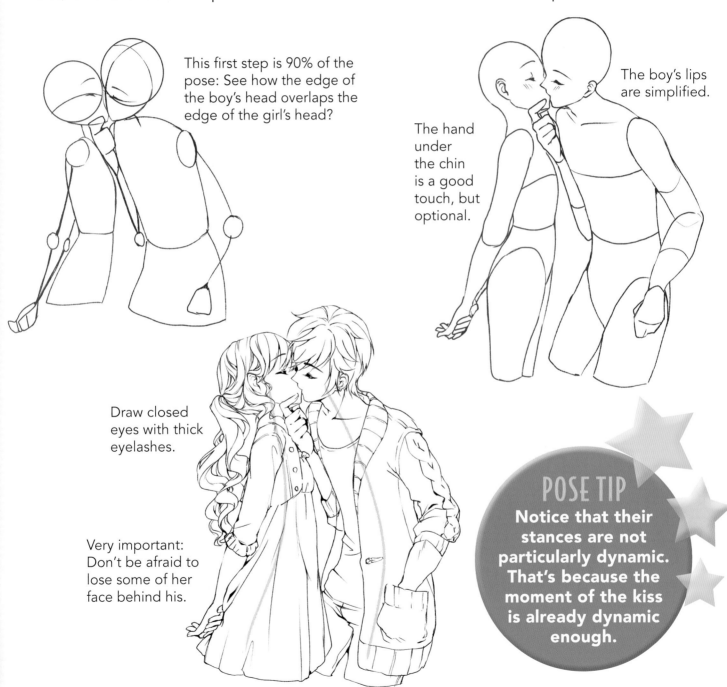

This first step is 90% of the pose: See how the edge of the boy's head overlaps the edge of the girl's head?

The hand under the chin is a good touch, but optional.

The boy's lips are simplified.

Draw closed eyes with thick eyelashes.

Very important: Don't be afraid to lose some of her face behind his.

POSE TIP
Notice that their stances are not particularly dynamic. That's because the moment of the kiss is already dynamic enough.

130

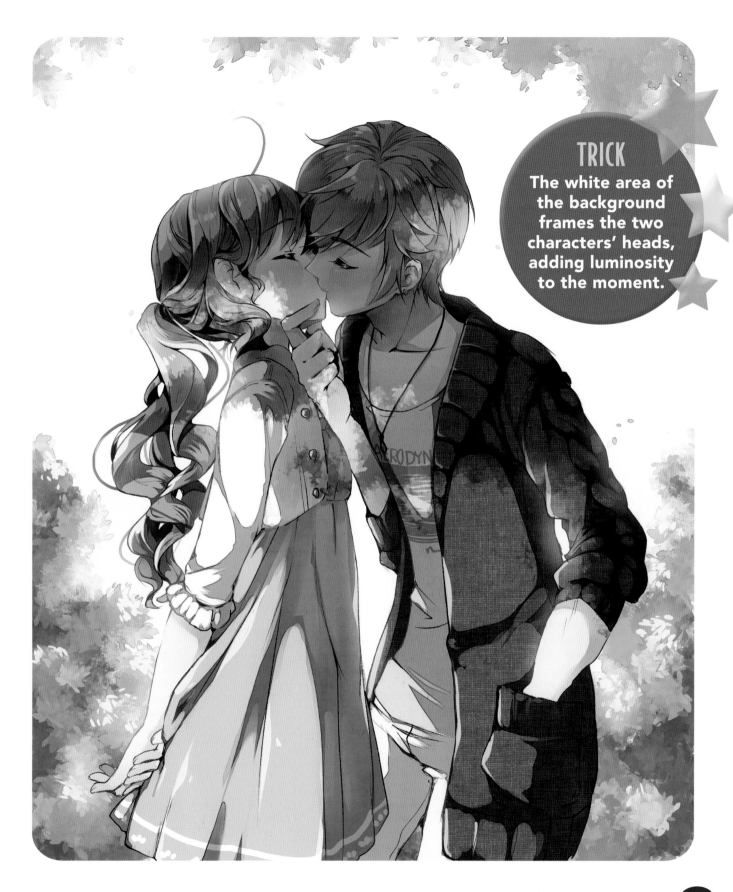

TRICK
The white area of the background frames the two characters' heads, adding luminosity to the moment.

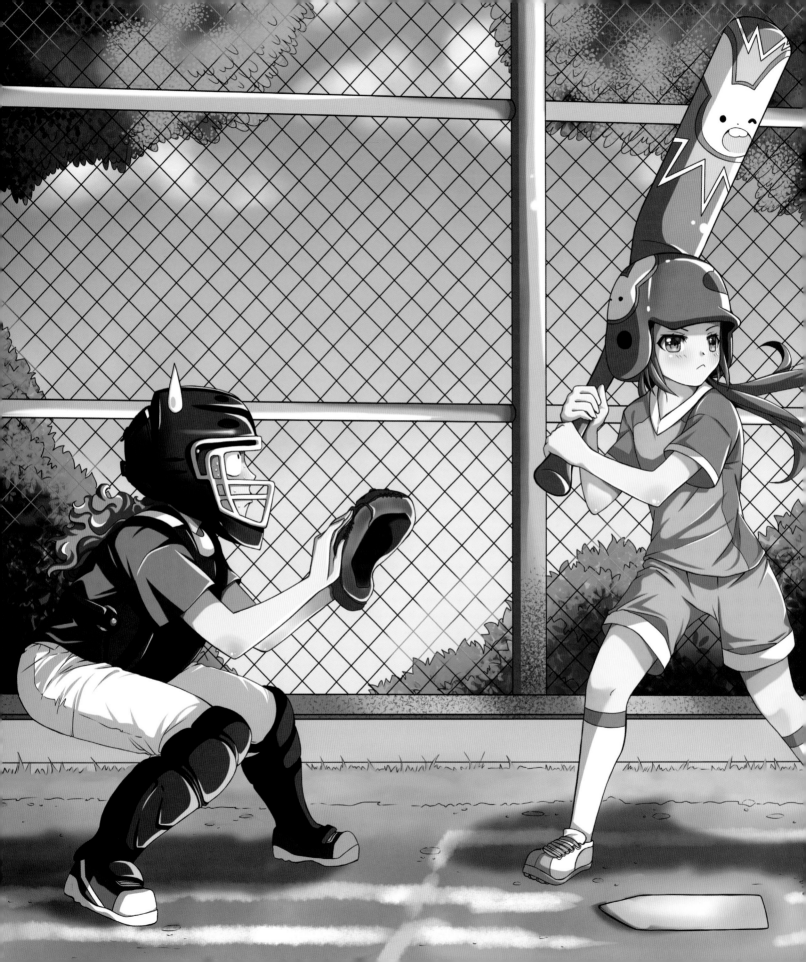

Drawing People in Backgrounds

Like a familiar outfit, audiences associate certain characters with certain settings. For example, if you have a character who always eats by himself in the school cafeteria, then that becomes identified with him. But the character must always remain prominent. This is done by paying attention to where you place the characters in a scene.

TIP
Match the setting to the character type.

The Kitchen

This teenager would rather eat her breakfast at the school vending machine, which has, like, the best sea salt caramel chips ever. Unfortunately, her mom knows the feed-the-dog-under-the-table trick. It can get you in trouble, but depending on what's being served, it might be worth it.

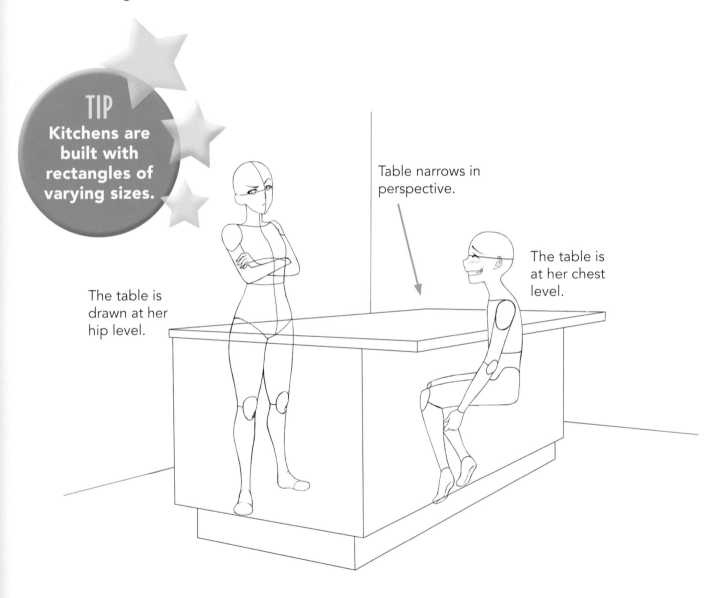

TIP
Kitchens are built with rectangles of varying sizes.

The table is drawn at her hip level.

Table narrows in perspective.

The table is at her chest level.

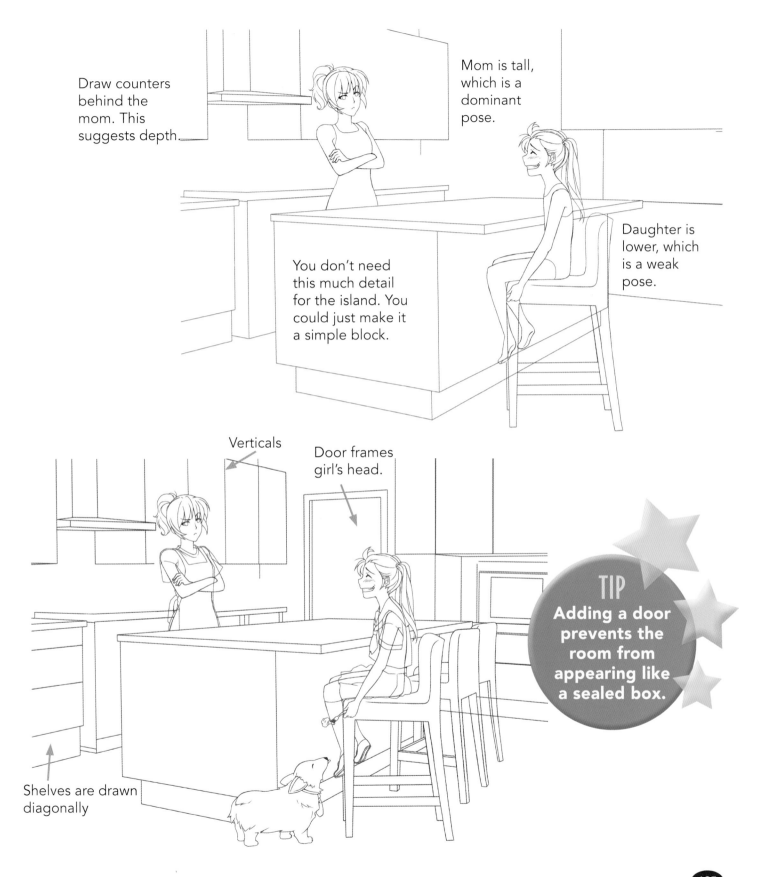

Draw counters behind the mom. This suggests depth.

Mom is tall, which is a dominant pose.

You don't need this much detail for the island. You could just make it a simple block.

Daughter is lower, which is a weak pose.

Verticals

Door frames girl's head.

Shelves are drawn diagonally

TIP
Adding a door prevents the room from appearing like a sealed box.

Any kitchen has a color theme. This one is white and tan.

The row of lights over the table adds an organizing principle to the layout.

Familiar items establish the kitchen area: microwave, stove and pots.

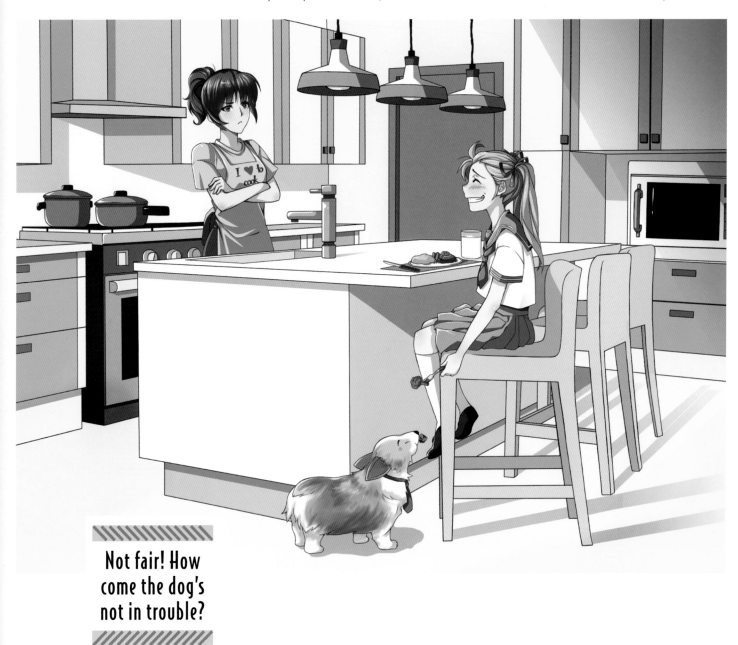

Not fair! How come the dog's not in trouble?

Baseball Diamond

Sports are huge in Japan, which is also the reason they're huge in anime. Here, we're focusing on one area of the baseball diamond, rather than the entire ball field and players. This allows us to direct the viewer's eye to the action.

TIP
Focusing on a specific area in a larger setting will help you direct the viewer's attention to the action.

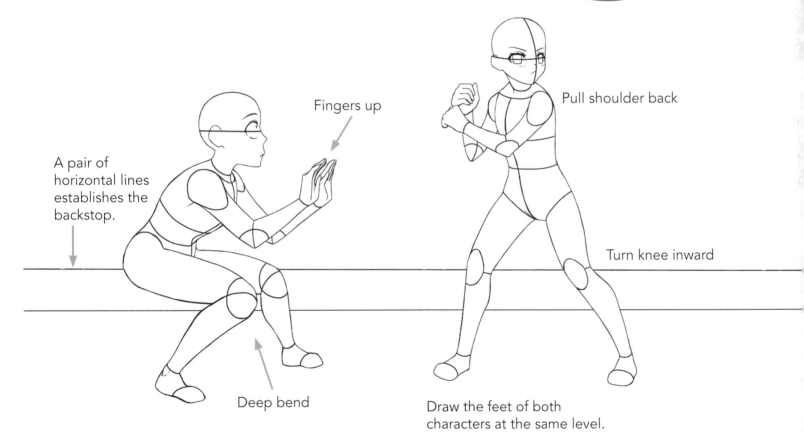

A pair of horizontal lines establishes the backstop.

Fingers up

Deep bend

Pull shoulder back

Turn knee inward

Draw the feet of both characters at the same level.

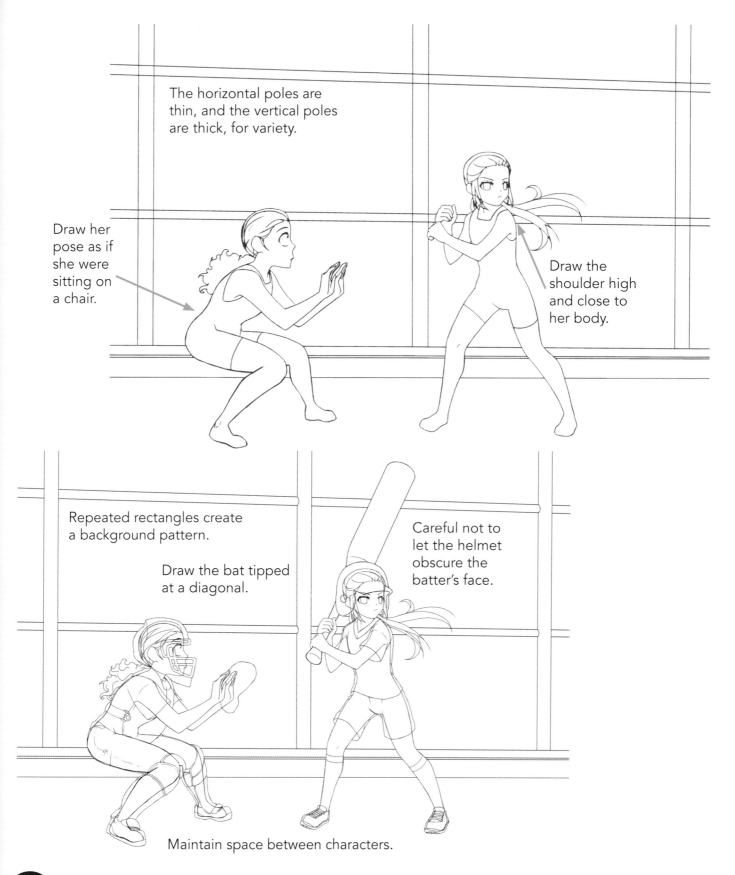

The horizontal poles are thin, and the vertical poles are thick, for variety.

Draw her pose as if she were sitting on a chair.

Draw the shoulder high and close to her body.

Repeated rectangles create a background pattern.

Draw the bat tipped at a diagonal.

Careful not to let the helmet obscure the batter's face.

Maintain space between characters.

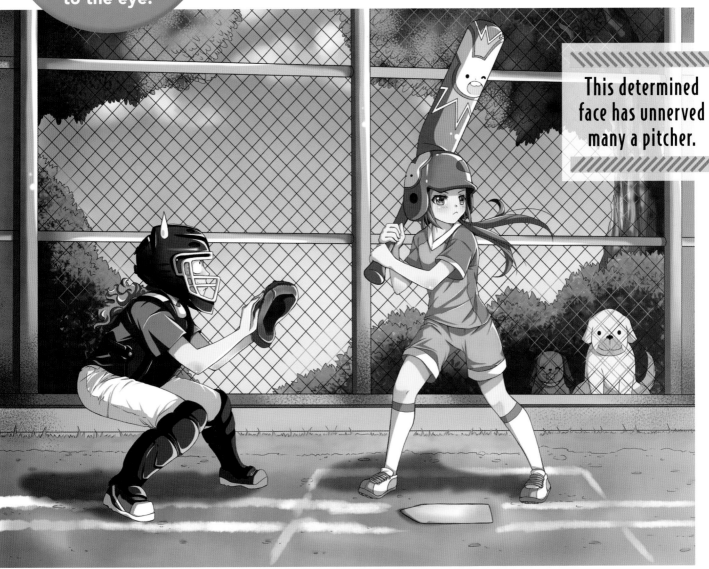

Science Lab

It happens every time: You're teaching a chemistry class, when a kid with a Bunsen burner accidentally knocks over a beaker and creates a plasma monster with an appetite for high schoolers.

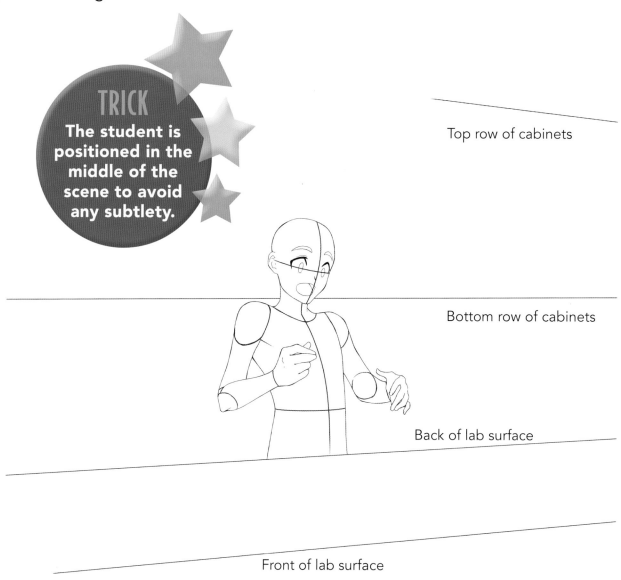

TRICK

The student is positioned in the middle of the scene to avoid any subtlety.

Top row of cabinets

Bottom row of cabinets

Back of lab surface

Front of lab surface

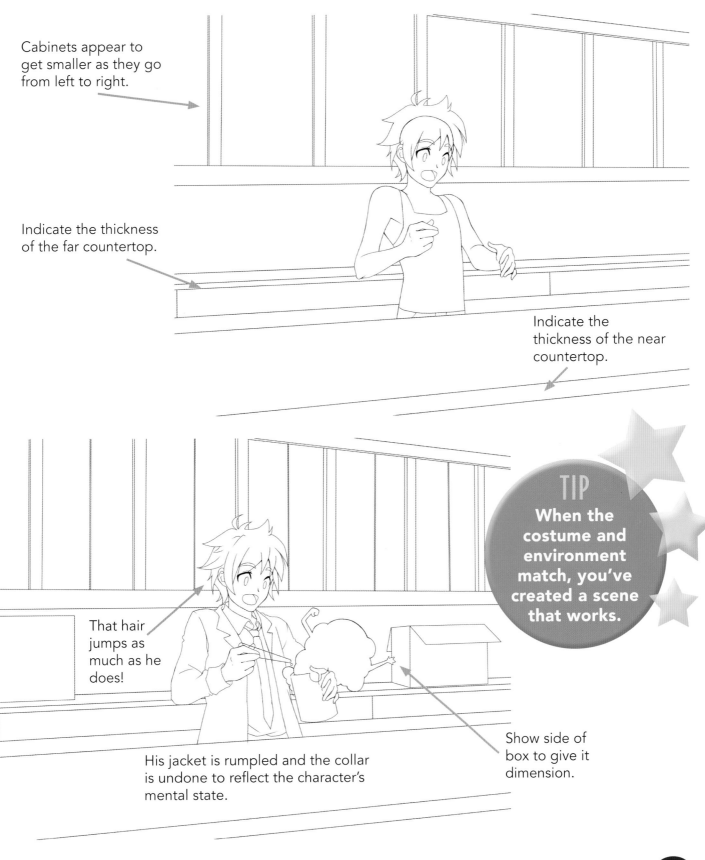

Cabinets appear to get smaller as they go from left to right.

Indicate the thickness of the far countertop.

Indicate the thickness of the near countertop.

That hair jumps as much as he does!

His jacket is rumpled and the collar is undone to reflect the character's mental state.

TIP
When the costume and environment match, you've created a scene that works.

Show side of box to give it dimension.

141

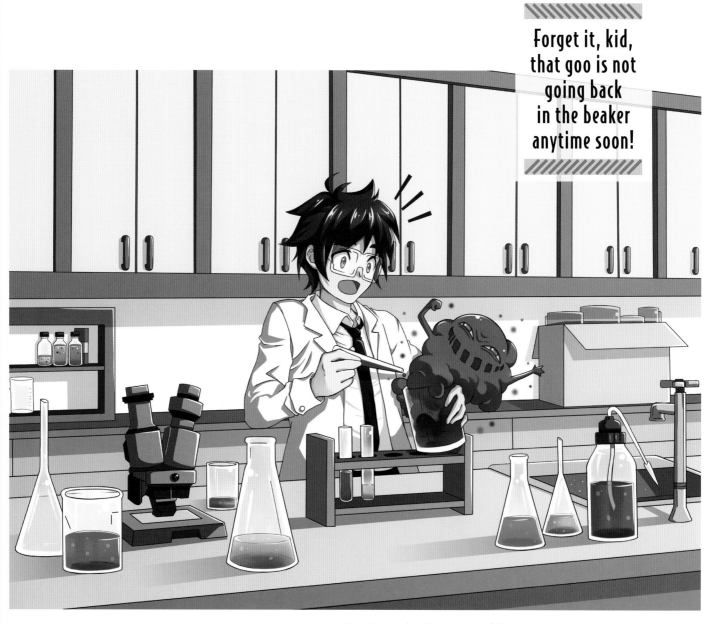

The colorful array of randomly placed beakers adds a lively look to the science lab.

Position the beakers of "pre-goo" away from the student, so as not to block the action.

Index

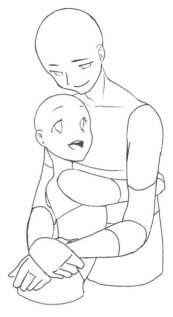